IMAGES
of America

SANTA PAULA

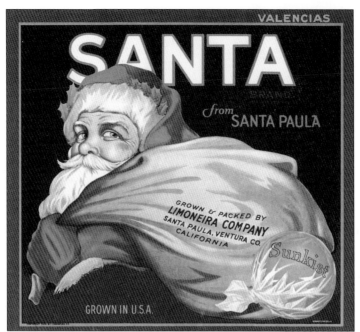

CITRUS PACKING LABELS, 1920S. These examples were used to promote two of the Limoneira Company's citrus brands. Such colorful advertisements, designed exclusively for the specific packinghouse, emerged with the expansion of the national railroad network. By the 1890s, the citrus business was blossoming and rail transportation eastward had opened a huge market for southern California-grown citrus. The competition was stiff among the major producers and their associated packinghouses. Such eye-catching identifications were ideal to advertise and promote the grower, the packinghouse, the grade of fruit, and its place of origin. Original labels continue to be popular collectibles.

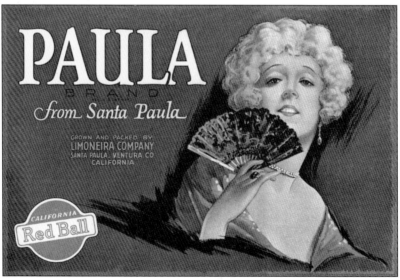

ON THE COVER: The historic Santa Paula Hardware Building, known as the "birthplace of the Union Oil Company of California," is currently home to the California Oil Museum. (Courtesy of the Santa Paula Historical Society.)

IMAGES
of America
SANTA PAULA

Mary Alice Orcutt Henderson

ARCADIA
PUBLISHING

Published by Arcadia Publishing
Charleston SC, Chicago IL, Portsmouth NH, San Francisco CA

Printed in the United States of America

Library of Congress Catalog Card Number: 2005939053

For all general information contact Arcadia Publishing at:
Telephone 843-853-2070
Fax 843-853-0044
E-mail sales@arcadiapublishing.com
For customer service and orders:
Toll-Free 1-888-313-2665

Visit us on the Internet at www.arcadiapublishing.com

*To my colleagues in history and the invincible spirit of Santa Paula's
pioneers past, present, and future.*

CONTENTS

ACKNOWLEDGMENTS

To begin with, there is a lack of correlation between the number of photographs representing the Mexican American families and their numbers in the community during the period covered. The reasons for this are twofold: their immigration did not occur until around 1900, and cameras or photographers were luxuries few could afford. It was not until the late 1930s that such items were affordable to a broader spectrum of the citizenry.

I am grateful for the input, correcting, and editing of Nancy Brogan, Anita Nelson, John Nichols, Bill Orcutt, Mike Shore, Mike Nelson, Judy Triem, Mitch Stone, and Alice and Anne Henderson. A very special thanks goes to Les Ammann, "my scan man."

To the following individuals, I offer my sincere appreciation for sharing their never-before-published family photographs:

Angela Preciado Dominguez
Celia Chavez Diaz
Frank and Mary Argüelles
Alice Lopez
Sam and Anita Salas
Ruth Taylor Kilday (Bascom and Taylor families)
William Milligan (White family)
Debera Fulstone Spear (Fagan family)
Patricia Alderson (Sharp family)
Ann Thille (Hardison family)
Robert Procter (Hardison family)
Irv Wilde (Todd family)
Jim Lyttle (Drown and Mott families)
Roy Wilson Jr. (Wilson family)
Sharon Del King Custer (Boles family)
Irene Tavis (Orne family)
Gale Graham (Henderson and Haines families)
Ruth Reddick Teague (Harry Teague family)
Virginia Richardson Gunderson (Richardson and Shively families)
Bettie Crawford Pycha (Crawford family)
Molly and Russell King (Corey house)
Janice Dickenson (airport photograph)
John Nichols (dam photograph)

These photographs are now a part of the Santa Paula Historical Society's photography collection, which was the main source of the book's images. For additional information and publications, please visit our website at www.santapaulahistoricalsociety.org.

INTRODUCTION

This work spans the first 60 years of Santa Paula's history, from the early 1870s to 1930. They were the determining years that led to its rise as a prospering city and its prominence in the state's annals for the both the citrus and oil industries. In order to understand how the initial settling occurred, a brief background is required.

Ironically, it was a failed farming venture that forced the subdivision of the Mexican land grant, Rancho Santa Paula y Saticoy. It is ironic because the area is ideally suited for farming with some of the richest soil in the world, a temperate coastal climate, moisture-laden fogs, and an average rainfall of some 20 inches. George Briggs came into this Santa Clara River Valley in 1862 and purchased the uncultivated 17,700-acre rancho to capitalize on these natural attributes. Since he was an experienced fruit grower from Northern California's Marysville, his scheme was to plant orchards of dry-farmed, soft-skin fruits that would ripen early and be the "first fruit of the season" at San Francisco's lucrative markets. Unfortunately, the planting of his thousands of saplings was followed by a series of the driest winters on record, and his young trees shriveled under the parching east winds and an unrelenting sun. Disheartened, in 1867 he authorized his agent to subdivide and liquidate his vast holdings and he quit the valley. His tragedy was a welcome opportunity for others.

For the first time, land-hungry farmers could purchase fertile, workable-sized parcels at affordable prices in legendary California. The newspaper advertisements sounded too good to be true, yet upon personal inspection, the glowing descriptions proved accurate. The climate was mild, with prevailing sea breezes; the soil was rich, as wild mustard was growing as high as a horse's eye; and water was plentiful, illustrated by the year-round flow of both the Santa Clara River and the Santa Paula Creek. Oak trees dotted the hillside, sycamores and alders lined the streams, and game was abundant. A handful of farmers came, investigated the advertised Briggs subdivision, purchased lands, and built homesteads. News spread and others quickly followed.

Land prices ranged from $10 to $25 an acre. A roster of these pioneers reveals that most hailed from New England or the Midwest. Many originally came to California seeking their fortunes in the fabled gold fields only to find little, but nearly all were experienced farmers who knew that the area's fine loam and superior environment made for endless growing opportunities. When the points of their collective plows dug into the fertile soil, Santa Paula took root.

The township was platted in 1873, but there was little to see save the tons of river rock and boulders strewn about the broad flood plain of Santa Paula Creek. Running through the valley was the lonely stage road, and where the settlement would start stood one dwelling and the only business establishment between Saugus on the east and San Buenaventura on the west—Billy Gordon's house and his "Pioneer Saloon." However, within just 30 years, budding citrus trees blossomed into a thriving business, oozing oil seeps gushed into the state's leading petroleum producing region, daily trains replaced the weekly stagecoach, and Santa Paula was incorporated. With a population of 1,900, it was second only to the county seat of Ventura in size, but in potential it was second to none.

How could this be possible in only three decades? Primarily it was the diligence, conviction and leadership of Nathan Weston Blanchard and Wallace Libbey Hardison. Between them, they helped establish the foundations upon which the two sustaining industries developed. In addition to this emerging commercial viability, they wholeheartedly threw their support and financial assistance to promoting and financing civic improvements and cultural enhancements for the betterment of their growing community. Due to their zeal and enthusiasm for California in general and Santa Paula in particular, they lured eastern colleagues and relatives to join them in this place of balmy winters and pleasant summers.

When it became a city in 1903, employment opportunities were many, due to the hundreds of farming- and oil-related jobs. Main Street was bustling, lovely neighborhoods were burgeoning, and an atmosphere of optimism kept everything humming. Such heady promise had been built by a collection of people who had fostered this potential by being industrious, frugal, community-minded, culturally mixed, and God-fearing. A popular high-school cheer summarized it best, "Oxnard buy the booze, Ventura by the sea, and Santa Paula by God!" But free from disaster Santa Paula was not. At the peak of its heyday, death and destruction struck with devastating force as floodwaters from the collapse of the St. Francis Dam surged in the dawning hours of March 13, 1928. The sleeping city was the unsuspecting victim of California's second-worst catastrophe. Over 400 lives were swept away that fateful morning, of which nearly 50 were Santa Paula residents. It took weeks, months, and even years for the city to regroup, rebuild, and return to normalcy. Recuperate and rejuvenate it did.

By 1930, the population had soared to 7,000 and Santa Paula was laying claim to its rightful legacies of both "citrus capital of the world" and "birthplace of the Union Oil Company of California." It had grown up with these young industries and was reaping the benefits from being a leader in production and technological advancements for both. The city looked back with pride on its historical birthright, ethnic diversity, and economic stability and looked forward to the future with the same resolute confidence and pioneer spirit.

The arrangement of this work reflects the author's feeling of what made Santa Paula grow and prosper during its initial 60 years. First, it was the people. Second, it was the industries they started that sustained them. Third, it was their Main Street, which is followed by their community of homes, churches, and schools. Lastly, it was how they spent their hours of leisure after the work was done—their pleasant pastimes.

One

THE PEOPLE

THE ORIGINAL PIONEER.
Jefferson Crane, the nephew
of George G. Briggs, joined
his uncle in 1862 to assist
in developing his doomed
200-acre, soft-skinned fruit
orchard. Though severe
drought spelled failure for
Briggs, young Crane remained
and did much to introduce
lima bean cultivation to the
coastal valley. He and his
wife, Janette Briggs Crane,
maintained a residence on
their 50-acre farm on the
Briggs subdivision for years.

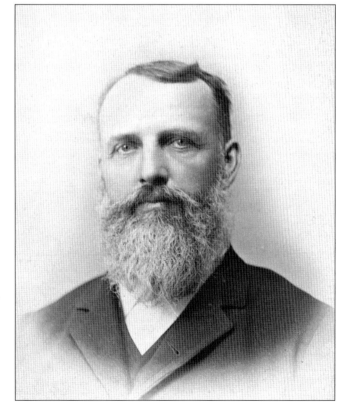

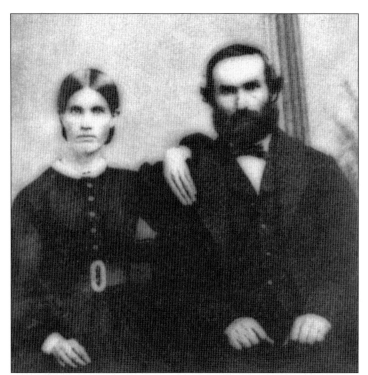

THE FIRST HOMESTEADERS. George Richardson secured a land patent on a quarter section south of the Santa Clara River in 1867. He came via the gold fields where he married Jenette Sims. After traveling through this lonely valley devoid of people, she observed, "You've brought us to the jumping off place now!" However, they succeeded even though she died 10 years later, leaving him a widower with five sons. The property remains in their descendants' hands.

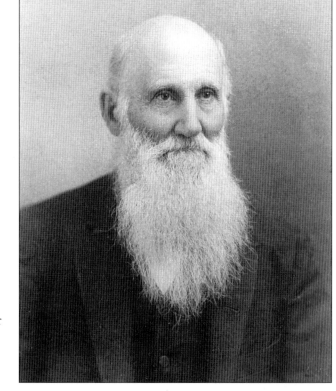

A PIONEER FARMER. Abner Haines was one of the luckless miners from the gold fields. Acquiring a 200-acre tract in the Briggs subdivision, he developed the property into a financial success. A contributor to the privately financed irrigation ditches, he was also a contributor to the area's reputation for bountiful crops.

LONG TIME COMING. Having found success in prospecting in the gold fields, Michael Fagan lost a fortune in wheat growing due to the unprecedented drought of 1864. He tried his luck at raising cotton in Mexico but was forced to flee when the insurgency toppled Maximilian. Around 1870, he settled in the canyon that bears his name, and unlike his farming neighbors, he pursued raising stock.

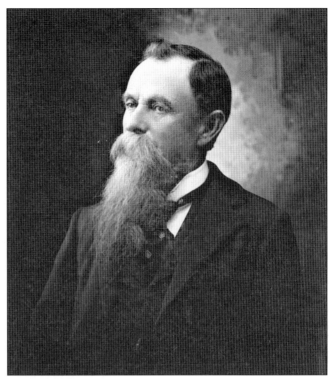

HATTIE TILLOTSON FAGAN. As the niece of Elisha L. Bradley, Nathan Blanchard's absentee partner, Fagan provides a shred of connection to an early prominent name that never even visited the town. Nonetheless, her marriage in 1879 to Michael found him well-established on his ranch up Fagan Canyon. There she birthed five children, and they raised them to lead successful lives.

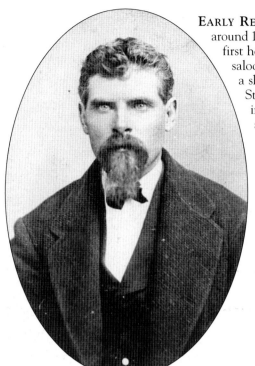

EARLY RESIDENT. Peter McMillan happened through around 1870 and stopped to help Billy Gordon build the first house and business establishment, his legendary saloon. McMillan was a blacksmith by trade, and in a short time he opened the original livery Eagle Stables. It was a business that became a Main Street institution. A later advertisement read, "We make a special effort to please Commercial Travelers and Picnic Parties."

LOCAL RENAISSANCE MAN. Samuel Peter Guiberson was a self-taught medical practitioner who went by the title of "doctor," and his Main Street office was a place of mystery and wonder. It was crammed with tomes of literature, science, law, metaphysics, and stuffed carcasses of local fauna. He wore a broad hat, black frock coat, carried a carved manzanita cane, studied law, and served as the first justice of the peace.

FATHER OF SANTA PAULA. This is the deserving recognition given Nathan Weston Blanchard. Representing his silent partner, Elisha L. Bradley, in 1872, he purchased 2,700 acres of the Briggs subdivision and made it pay off. He not only founded the town, but he also established the citrus industry, promoted education, and fostered culture in the community. His ultimate contribution was the cofounding of the Limoneira Company.

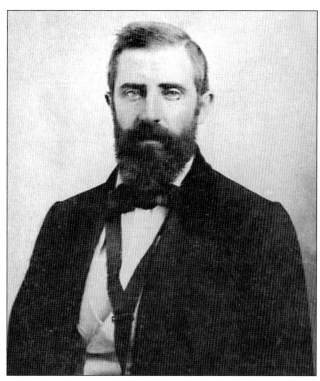

ANN ELIZABETH HOBBS BLANCHARD. Like her husband (above), she was a native of Maine. The couple married in San Francisco after he brought her out to see "his" California under the chaperonage of her sister-in-law and brother. As newlyweds, they settled in the gold town of Dutch Flats, where he ran a profitable lumbering operation. The untimely death of their son, Dean Hobbs Blanchard, prompted them to remove to this area in 1872.

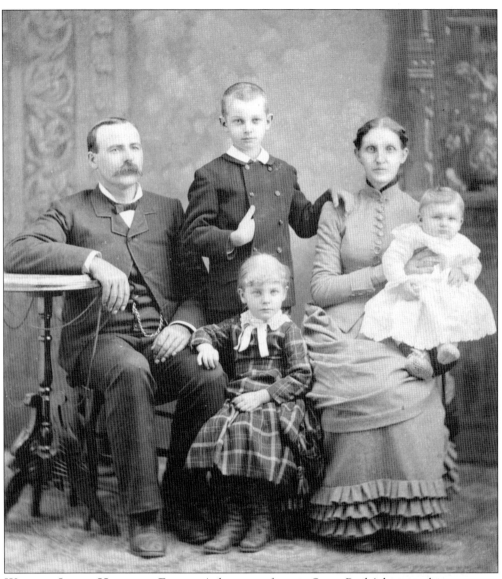

WALLACE LIBBEY HARDISON FAMILY. A dominant force in Santa Paula's historical importance, "W. L." was the cofounder of both oil and citrus companies. He was also a generous contributor to the Santa Paula Academy, the Universalist Church, and many other civic improvements. Due to his charisma and spirit, siblings and relatives followed him west. Pictured, from left to right, are W. L., Guy (standing center), Augusta (seated center), and Clara MacDonald Hardison (holding Hope).

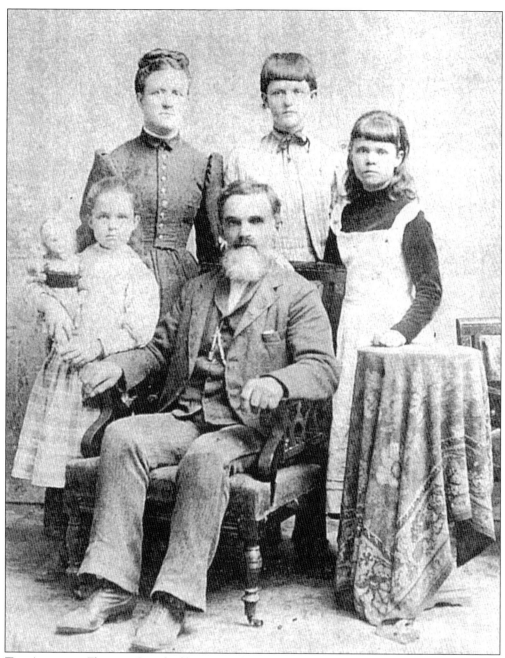

THE ARBORIST. Ebenezer Orne had been a Methodist circuit rider and teacher in the gold fields, but with the coming of another baby, his wife insisted that he quit that rugged lifestyle. After stopping to see relatives living in Santa Paula when she was ready to have their baby, they decided not to leave. In his flourishing garden, he planted the seed that grew into the magnificent Moreton bay fig tree. Pictured, from left to right, are Cora, wife Eliza, Ebeneezer (seated), Lizzie, and Grace.

A PROMOTER. Charles N. Baker, a stagecoach driver who tore through the valley, watched the town grow to his liking. Knowing that the railroad was coming, he settled down to capitalize on the pending changes by building the Union Hotel. When it burned, he partnered with Thomas O. Toland and opened Main Street's first real estate and insurance office, which thrived. He also served on the county board of supervisors.

JAMES SHARP. Born in Ohio, James was raised in Oregon. Coming south to California, he took odd jobs before attending the State Normal School in San Francisco where he met and wooed Susanna Rebecca Plank. Coming to Santa Paula in 1882, he purchased a 150-acre piece in the Briggs subdivision. Starting with dry-farmed crops, he eventually developed the ranch into fine orchards enhanced with a splendid home.

16

SUSANNA REBECCA PLANK SHARP. Born in Pennsylvania, she and her parents came to California after receiving enticing letters from her brother Heber. She too attended the State Normal School in pursuit of her teaching credentials, but fellow student James Sharp interrupted her plans. On their farm they raised six children, which left no time for teaching.

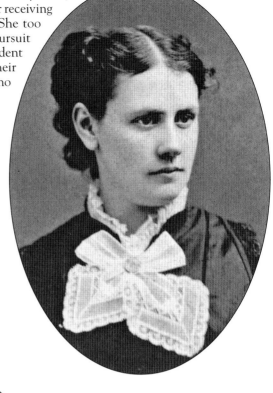

A SHARP DAUGHTER. Grace was the eldest girl born to James and Susanna. She graduated from the Santa Paula High School in 1895 and continued on to Berkeley, where she transferred to Cooper Medical School, from which she graduated in 1899. Dr. Sharp was one of California's first female physicians. Practicing but a few years, she turned her attention to other interests like her longtime neighbor, John Thille, whom she married.

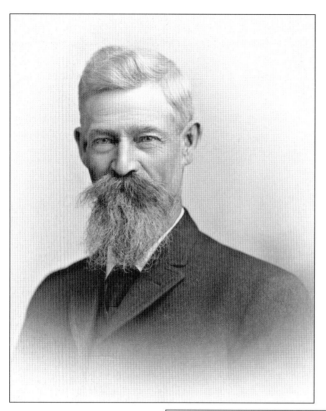

AN EAST SIDE FARMER. Glowing letters from John Orcutt's in-laws, Anna and Eben Moore, brought him and his family in 1882. Acquiring a section adjoining Moore's, Orcutt both homesteaded and purchased the lower portion from the Southern Pacific Railroad, who had received the right-of-way through federal land grants. The first year's lima bean profits paid off his property's mortgage.

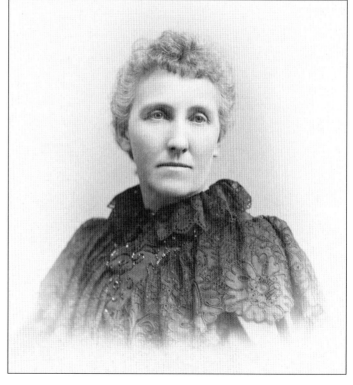

A RESOURCEFUL LADY. Anna Mary Logan came in 1887 as a widow with three children. Choosing Santa Paula because her sister Sarah and husband George Fleisher were here, she purchased three lots on Mill Street that had two houses. They lived in one and rented one, and they saved enough to build their home, which is still called the "Logan House." Such business savvy made her one of the town's early businesswomen. The later marriage of Will Orcutt and Mary Logan united the two families.

A MAN OF PROMINENCE. Charles McKevett arrived in 1886 and shrewdly capitalized on his financial resources. Purchasing 425 acres of land, he subdivided the lower portion, where splendid Victorian homes appeared and maintained the upper portion in agriculture. Anxious to benefit from the town's growth, in 1888 he organized both the First National Bank of Santa Paula and the People's Lumber Company. He and his wife contributed unsparingly to civic endeavors.

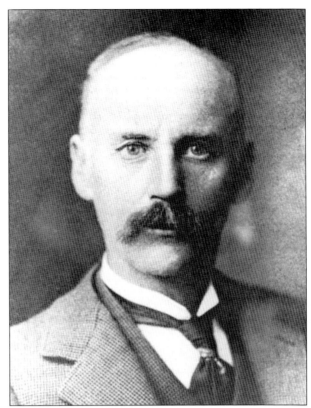

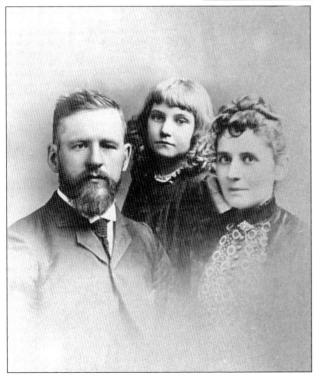

SANTA PAULA'S FIRST PHYSICIAN. With black bag, wife, and daughter in tow, Dr. David Mott hung his shingle in 1888. A graduate of Cornell and then the University of Michigan's medical school, he was beloved in the community for the generations of babies birthed, broken bones mended, ailments cured, and surgeries performed. After retirement, he was elected to the state legislature. Pictured, from left to right, are the good doctor, Arley, and Emma Drown Mott.

19

ALTON LUCIUS DROWN. Emma Mott's younger brother, Alton, arrived shortly after she and her husband did. Soon partnering with liveryman Frank Davis, they operated the rambling Davis and Drown "Champion Stables" for years. When he became financially solvent, he married Gertrude Logan and settled into a life of raising daughters, promoting civic improvements, and contributing years as a founding director of the Santa Paula Building Association, furthering its financial success.

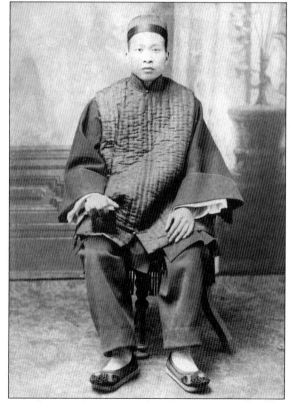

AH YOUNG. This stoic Asian man was Santa Paula's first laundry man, but there is a lack of information about him. According to an early resident, there was a Chinese laundry in the alley below Main, and presumably this was his place. She further explained that it had a corrugated tin roof, which "white hooligans" were known to lob rocks on just to see the workers run out in panic.

MORE THAN A TEACHER. In the annals of California's history of education, Olive Mann Isbell is famous for being the first grammar-school teacher to instruct in California in the 1850s. Years later, she and her husband settled in Santa Paula, and the junior high school was named in her honor because of her contributions to education. She is pictured here with neighbor and helper Champ Fansler.

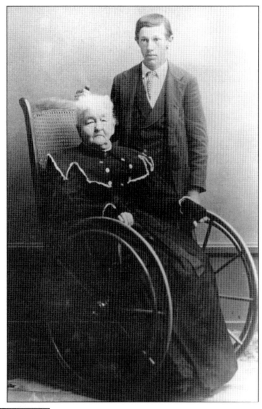

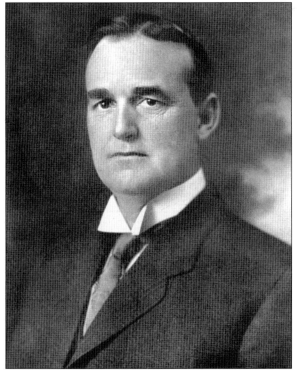

A COMMUNITY LEADER AND INDUSTRY PIONEER. Charles Collins Teague, a grandnephew of Wallace Hardison, learned the citrus business from Nathan Blanchard. When he married Harriet McKevett, he had covered all the bases to rightly assume management of Limoneira in 1898. Under his superb supervision, the next 50 years saw the company dramatically advance due to his innovative ideas and cost-saving breakthroughs, and urging the establishment of the marketing association called "Sunkist."

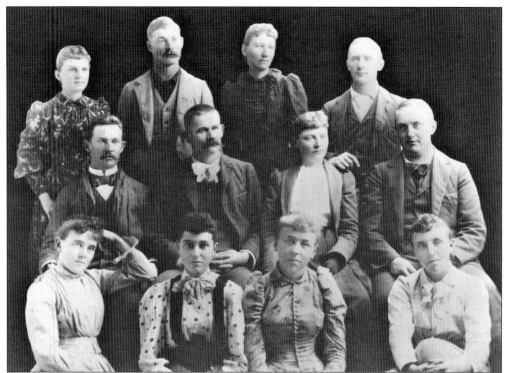

FRIENDS AND SWEETHEARTS, C. 1893. Some of Santa Paula's young adults, pictured here from left to right, are (first row) Jessie Courts, Rena Clarke, Anna Schromyer, and Mary Logan; (second row) Norman Say, Alton Drown, Gertrude Drown, and Leroy Beckley; and (third row) Jennie Scott, Will Orcutt, Estella Bishop, and Clarence Beckley. The result? The future marriages that would originate from this group were Mary and Will Orcutt, Gertrude and Alton Drown, Lorena and Clarence Beckley, Jessie and Norman Say, and Anna and Leroy Beckley.

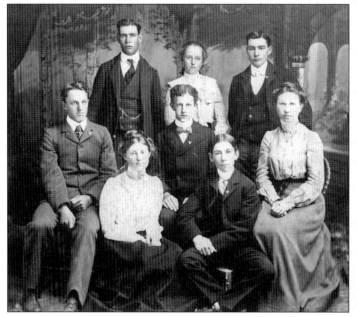

CLASS OF 1901. The graduating seniors of the Santa Paula High School, from left to right, are (seated) Arthur De Nure, Beatrice Todd, Everett Condit, Roy Henderson, and Edna Blanchard; and (standing) Harold Fleisher, Ernestine Todd, and Horatio Mahan. Many of the annual graduates matriculated to such institutions as Stanford University, the University of California, Occidental College, and the University of Southern California.

A GAME GAL. This was either a gag or a promotional shot for the farrier. However, in addition to being a local character, Vesta Fansler was a gifted pianist and the town's first woman telegrapher in the depot. Shortly after this photograph was taken, she married another local eccentric, Herman Keene. Among other occupations, he was a famed mountain man, rattlesnake killer, and lion hunter.

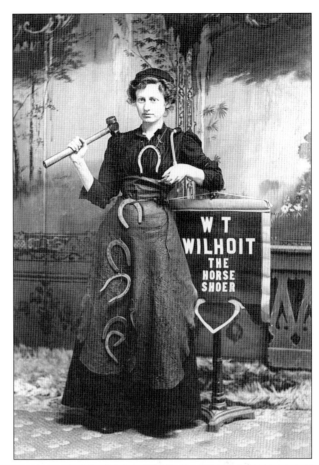

THE FAGAN FAMILY, C. 1900. Pictured, from left to right, are (first row) Hattie, Frank, Cora, and Walter; and (second row) Frank, Etta, and Marion.

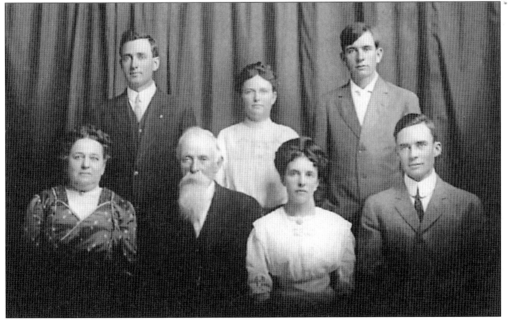

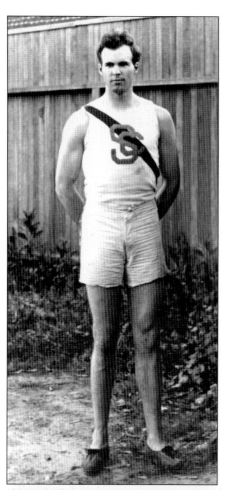

ATHLETE, GENTLEMAN, POPULAR JOCK. Charlie Richardson was Santa Paula's, and the county's, premier track-and-field man from 1904 to 1906. He excelled in the pole vault, running broad jump, shot put, hammer throw, high jump, and the relays. Dashing off as a freshman to the University of Southern California, his athletic prowess continued to wow coeds, colleagues, and spectators. In August 1908, his spectacular career came to a crashing end off Port Hueneme, where he drowned in the pounding surf.

JOHN BASCOM TAYLOR FAMILY, C. 1914. Reverend Taylor was an itinerant preacher in the Santa Clara Valley in the late 1890s. His circuit stretched from Fillmore to Moorpark. The family moved to Santa Paula during the high-school years of their children. Pictured, from left to right, are (first row) Reverend John, granddaughter Ruth, wife India Belle, grandson Gould, and Paul; and (second row) Arthur, daughter-in-law Rachel, Sherrill, Maude, and John (who married Rachel).

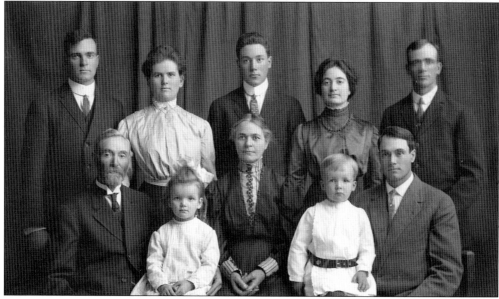

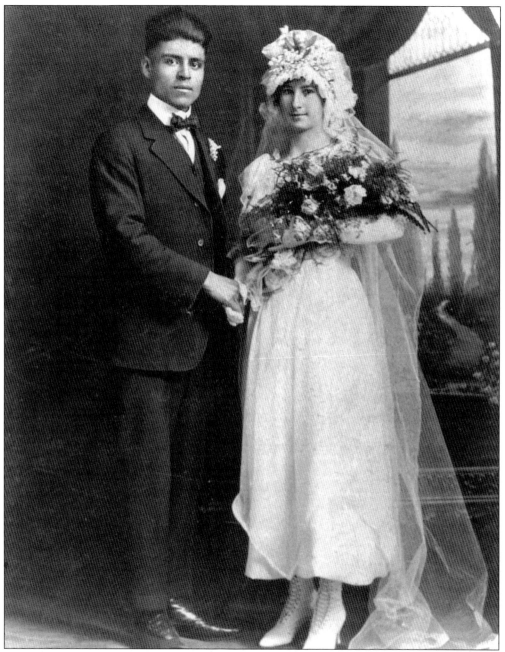

MARRIAGE. When Julio Argüelles married the lovely Carmen Garcia in 1918, two prominent families were united. Their grandson Eddie remains a legendary high-school teacher.

LOTTERY TICKET NO. 02005.
Local son Douglas Shively's number was drawn in the first round of the national draft for World War I. Between adopting the government's food-rationing and giving liberally to the continual pleas for Liberty Bond subscriptions, the town of around 3,000 also gave seven young men: Carl Carter, Raymond Craig, Frank G. Davis, John Hernandez, Earle Ingalls, Frank Fernandez, and Paul Reid.

COUNTY'S FIRST LICENSED ARCHITECT.
Roy Wilson Sr. was hired by the McKevett Corporation in 1922 to organize its building department and direct the development of the McKevett Heights neighborhood. Along Main Street, the rise of spacious buildings with stunning facades prompted the newspaper to crow, "The beauty of a city depends to a very great extent upon the architecture of its buildings," and Wilson was, to a great extent, responsible.

SISTERS AND AMIGAS. Elvira, at left, and Esther Chavez grew up in Santa Paula. In 1924, Elvira married Luis Leon. As the family matriarch, she raised the children in the strictest Victorian tradition with love, support, and a good sense of humor. She enjoyed needlework, interior decorating, and cooking. Among their daughters is Celia Leon Diaz, the next-generation matriarch of the Tony Diaz family.

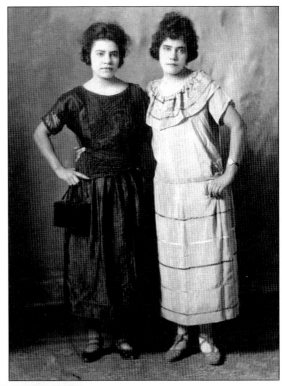

A DASHING SEÑOR, 1927. Luis Leon fled Mexico during the Mexican Revolution of 1910 and settled in Santa Paula. An avid reader with a flair for words, he used his gift in addressing many Spanish-speaking functions as well as hosting a bilingual program at the fledging local KSPA radio station from the late 1930s to the early 1940s. He was assertive, proud, and forever writing poetry on any available surface.

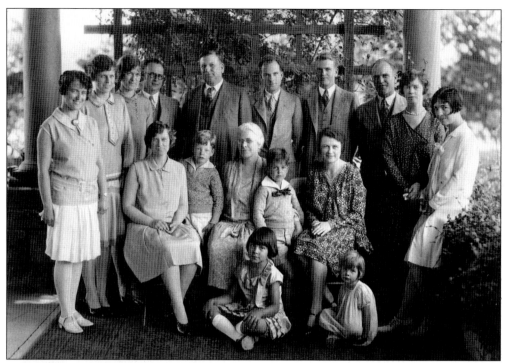

ALLEN CROSBY HARDISON FAMILY, 1928. Another nephew of W. L. Hardison, A. C. graduated with a degree in civil engineering and assumed various duties related to his training or family businesses. His wife, Cora, was the daughter of Jefferson Crane. Pictured here, from left to right, are (first row) granddaughter Virginia and granddaughter Meredith; (second row) Ruth, grandson Roger, mother Cora, grandson Allen, Helen; and (third row) Coralynn, Janette, Louise, Domingo, "A. C.," Wallace, Robert, Warren, Alice (Warren's wife), and Nina (Domingo's wife).

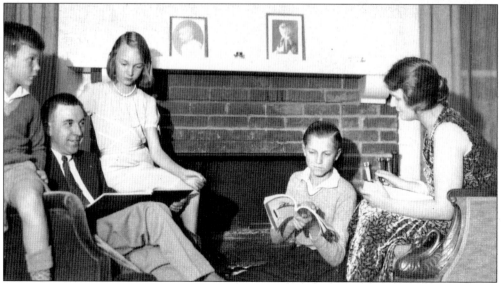

A CHRISTMAS CARD PHOTOGRAPH, 1929-STYLE. City engineer Harry Reddick poses with his family. Pictured, from left to right, are Robert, father Harry, Ruth (Teague), Harry Jr., and mother Ruth.

Two

THE SEEDS
THEY PLANTED

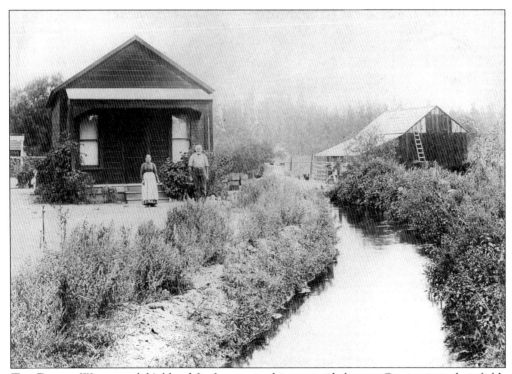

THE DITCH. Water was life's blood for farmers in this semiarid climate. Getting it to their fields was foremost in their plans of development, so they formed Farmers Ditch Irrigating Company to finance it. When completed, it was one of four such privately owned enterprises. Diversion gates were located along the Santa Paula Creek or the Santa Clara River. The open ditches were later replaced with concrete pipes.

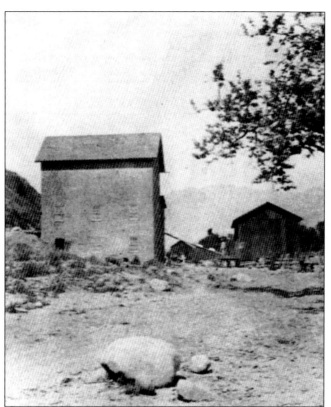

SANTA PAULA FLOUR MILL. As the settlement's first industry, this three-story wooden structure opened for business in May 1872. Its hydropowered turbine was propelled by water dropping 110 feet from a ditch on the hill behind. Built and owned by the Blanchard and Bradley partnership, it was the only flour mill between Los Angeles and San Luis Obispo. At the centennial celebration in Philadelphia, the mill's Middlings Purified brand captured a blue ribbon.

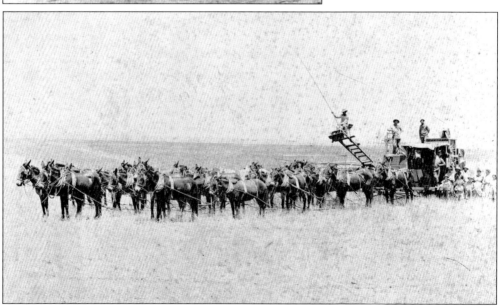

COMBINE HARVESTER. Mule-drawn machinery combined the cutting and processing of wheat into one operation that was a great improvement in technology. Vast fields were grown in the drier valleys, providing Santa Paula's flour mill its sustenance. The great machines were pulled by teams of 26 animals, six abreast. Notice the position and location of the whip-wielding teamster—his was a risky spot indeed.

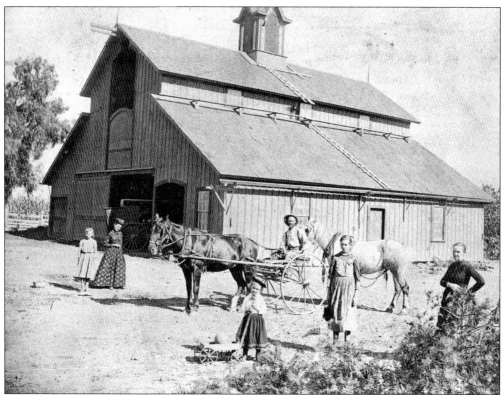

HAY AND EQUIPMENT BARN, C. 1880. George Washington Faulkner sat in his rig for this photograph. The names of his family were not identified. Faulkner was among the earliest settlers and developed one of the area's finest farms. The massive redwood barn remains a focal point of his homestead at 14292 West Telegraph Road.

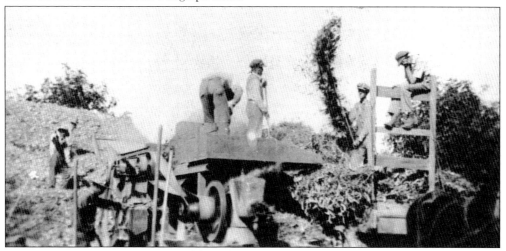

PITCHIN' LIMA BEANS. Dry-farmed lima beans were the number-one cash crop in the 1880s. So many tons were harvested in the coastal valleys that the region was known as "Bean County, U.S.A." The legume thrived under the moisture-laden ocean fogs, and the mature plants were dried by the hot, east winds of fall. At harvest time, huge machines were heard and seen from dawn until fog rolled in or rain fell. The crop was major through World War I.

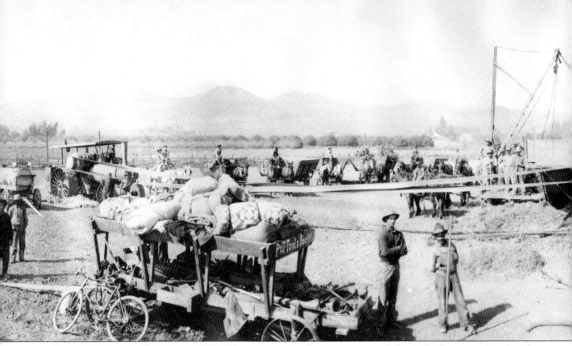

FROM BEANS TO BAGS, C. 1920. The tractor in the rear powered the belt that ran the thresher. Lined up were the "net wagons," so called because nets in the bottom held the dried bean vines. When driven up to the towering derrick, its dangling hook grabbed the net, and when the team pulled forward, the raised net was cinched closed. Then the derrick man swung it over and released the vines onto the platform. From there, "hoedowns" forked the vines to the feeders, who forked

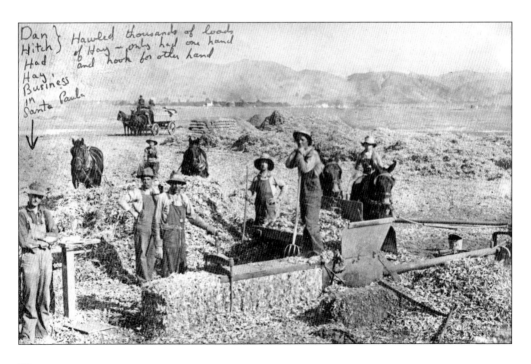

Dan Hitch } Hauled thousands of loads of Hay — only had one hand and hook for other hand
Had Hay Business in Santa Paula
↓

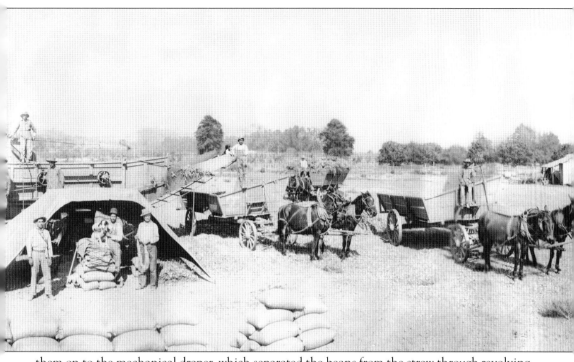

them on to the mechanical draper, which separated the beans from the straw through revolving sieves. The straw was blown out into a wagon, and the clean beans were sent down the chute to the "sack sewer" sitting in the tent. Using a large hooked needle and heavy twine, he sewed the cotton sacks into 25-pound bags of limas. Stacked in front were the finished products.

BALING BEAN STRAW. The annual tons of limas harvested in turn generated huge amounts of chaff or bean straw. As the photograph on the opposite page shows, Dan Hitch and his crew took the unwanted straw and converted them into bales that were standardized in dimensions and weight, hence the need for the scale at left. When baled, it was sold as either inexpensive stock feed or as material to be spread on the dirt roads to keep the dust down.

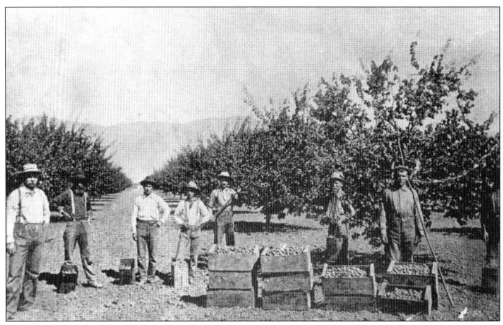

ANOTHER IMPORTANT CASH CROP. Dry-farmed apricots were a premier crop during the 1890s. Typical crews were families, many coming from Los Angeles, who took the summer harvest as a time for being in the country, working together, and earning some extra money. It was an annual outing, and many returned to the same ranch every year. Usually the ranchers provided tents, showers, and restrooms. Meals were prepared at communal outdoor kitchens.

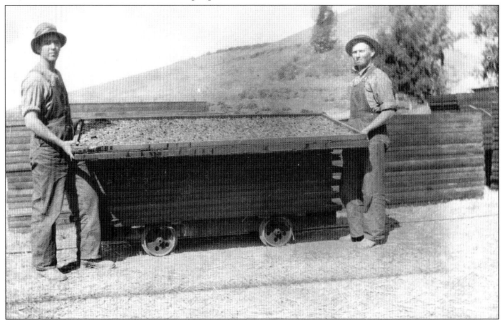

MINI-RAIL SYSTEMS. Larger apricot farms had a system of tracks in the orchard that led into the sulphur-smoking house, to the pitting sheds, and to the drying areas. As these men demonstrate, the filled trays were stacked on the rail cars. The chassis and tracks were often recycled from abandoned mines. Such systems delighted children in the off-season.

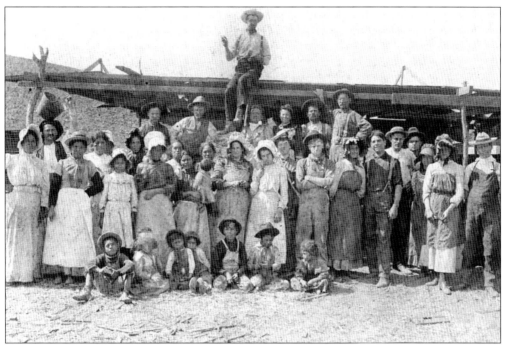

TYPICAL CREW BY THE PITTING SHED. Men and boys did the heavy work of picking and hauling lugs and trays. Women and girls pitted the fruit, which involved holding the " 'cot" in one hand and splitting it in half with a sharp, specialized knife. Nimble fingers paid off, for payment was based upon the number of trays pitted. The pitter earned a ticket for each full tray, which was redeemed at the end of the day. The going rate was 25¢ a ticket.

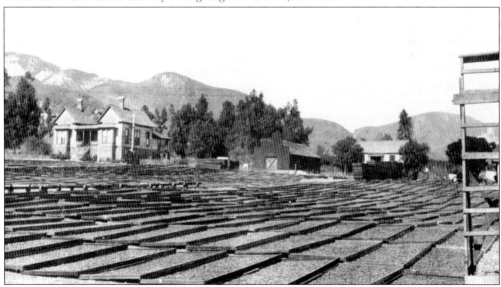

TO CONCLUDE THE APRICOT CURING PROCESS. In the center of the photograph is the sulphur house where the trays were left overnight to be "smoked" in order for the fruit not to turn brown. The trays were then laid in the sun to dry out completely. The finished product was bagged in white sacks and taken to the local Southern Pacific Milling Company's warehouse for storage and sale—when the price was right.

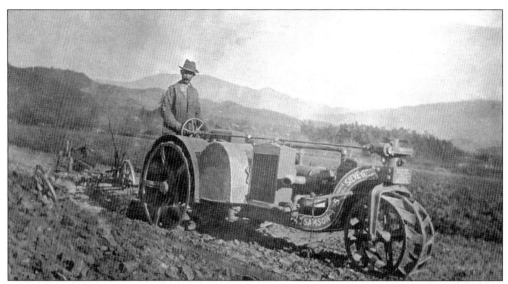

THOROUGHLY MODERN MACHINERY, C. 1920S. Fred Smith, owner and operator of this Samson Sieve Gripper Tractor, was working his field west of town. Such mechanization at this time was revolutionary for those who could afford such a contraption. Tractors did not become commonplace until the late 1940s.

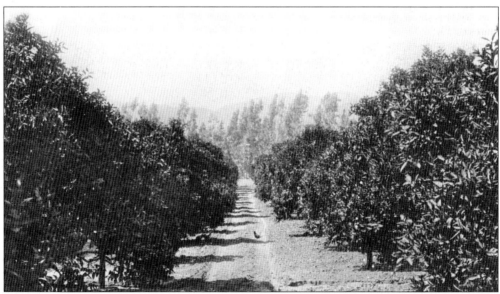

THE TREES THAT PRODUCED AN INDUSTRY. Nathan Weston Blanchard's experimental 100-acre irrigated orchard, planted in 1874, took 18 years to produce. Experts surmised that such slow bearing is characteristic of seedling trees. Even before producing, 36 acres were budded to lemons. However, when the trees did produce, the fruit proved to be of exceptional quality. The approximate boundaries of the grove were Fagan Barranca to Palm Avenue and from Main to Pleasant Streets.

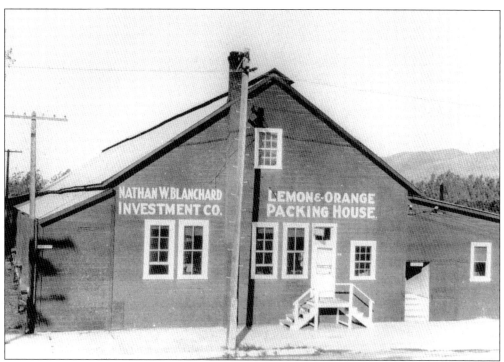

A County First. Blanchard's long-awaited production from his orchard demanded construction of this packinghouse by 1888. Presumably, he patterned the design on those he had observed in the Riverside/Redlands citrus areas. Built along the rail line at the intersection of Main and Palm Streets, this small operation led to the prospering industry that flourishes today. The photograph dates to 1903.

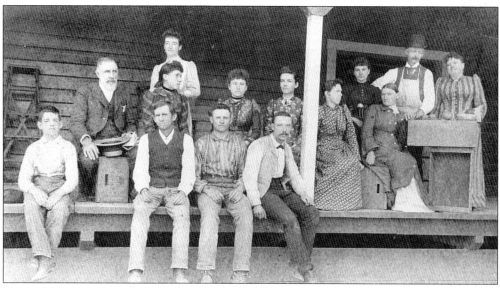

Early Packinghouse Crew with the Boss. The group posing on the facility's back porch, from left to right, are (sitting in front) Ervy Skinner, Will ?, Mort Hatcher, and Mr. Mason; (sitting in back) Nathan Weston Blanchard, Ann Robinson, Rena Shick, Jennie Skinner, Ida Shick, and Mrs. Young; and (standing) unidentified, Mrs. Byers, A. D. Williams, and Mrs. Starr.

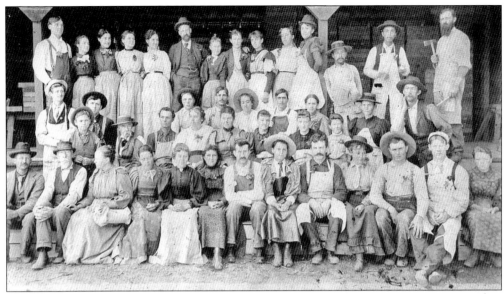

BLANCHARD'S EMPLOYEES, 1890. As production increased, so did the personnel. This appears to be the assembling of all of Blanchard's employees, from field hands to the packinghouse crew. The man in the back row, wearing the suit, was Blanchard's son Nathan. The job classification of the man wielding the axe is unknown.

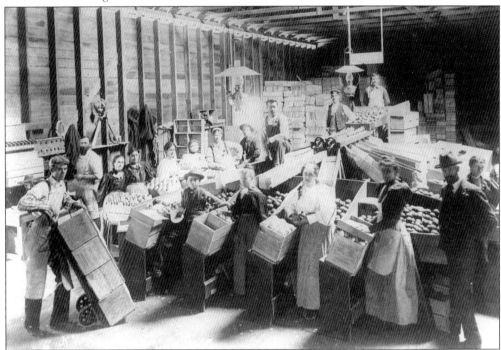

BLANCHARD PACKINGHOUSE INTERIOR, 1890s. This was the area where women hand-graded and hand-packed the fruit into wooden crates. Each piece of fruit was individually wrapped in preprinted, tissue-like paper to both protect it during shipping and advertise the packinghouse. The young man balancing the dolly, with four packed crates, will take them to the basement for storage until it is shipped by rail.

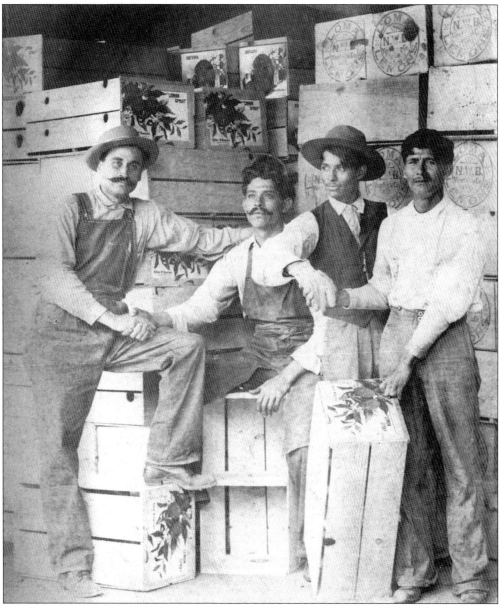

THE CARPENTRY CREW, 1909. These men made the shipping crates for the Blanchard packinghouse. They were fashioned from low-grade pine or fir. The house name and grade of lemons were hand-stenciled on each side, and the paper-advertising label that was glued on each end read, "Lemon Spray," for Blanchard's Loma Lemons grade. In this photograph, only Leon Preciado (left) is identified.

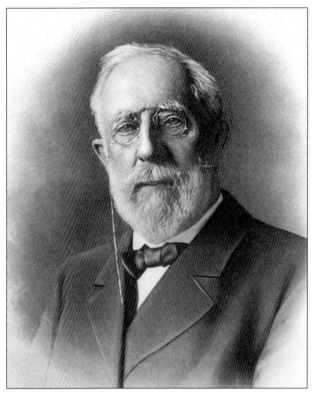

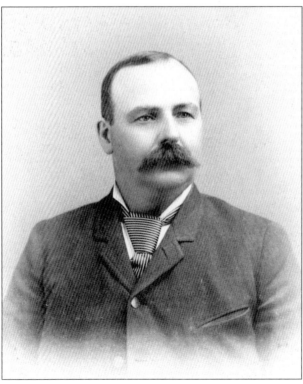

LIMONEIRA RANCH COMPANY INCORPORATORS. Nathan Blanchard's (at left) citrus was an unqualified success. His oranges were sweet and juicy and his lemons most sour. He had taken a chance of sending a sample shipment to a fruit broker in Chicago. Using the new refrigerated train cars guaranteed that his fruit arrived in excellent condition. The broker's response echoed what the locals had been saying: "Delicious!" With the promise of an expanded market, Blanchard was eager to expand his operations. As luck would have it, his associate and citrus-growing colleague Wallace Hardison (below) happened to be looking for a new venture. Having left Union Oil and experimenting with raising citrus on his ranch, Hardison decided to collaborate with Blanchard. In late 1891, the two men purchased a 413-acre track on the west side of town and employed a Glendora nurseryman to grow thousands of seedling trees for planting. Prepared to incorporate, as a precautionary step they brought in some stockholders in the event the current economic hard time became even harder. The papers for the Limoneira Company were signed in March 1893 with a stock value of $1 million and the rest is history.

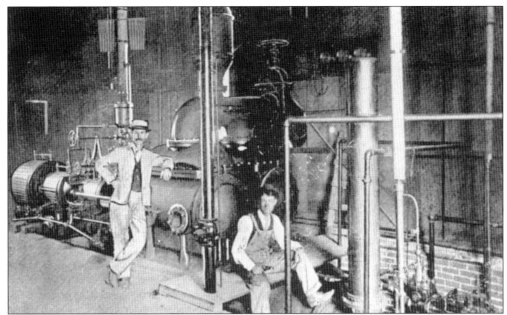

THERMAL BELT WATER COMPANY, C. 1894. This is one of the two companies developed to deliver irrigation water to Limoneira, the diverted flow from the Santa Paula Creek that was carried in a 22-inch pipeline. To help finance it, stock was purchased by neighboring farmers who shared the water. The pictured 85-horsepower, high-pressure steam boiler made this pumping plant the envy of many private water companies. Its modern successor remains at the intersection of Palm and Main Streets.

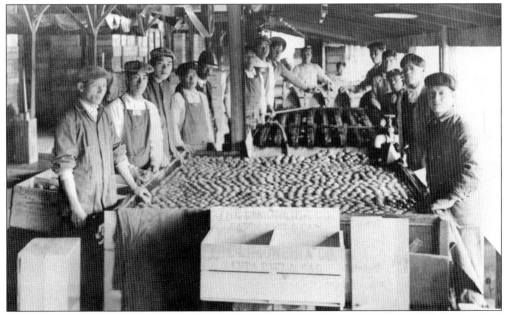

TYPICAL LABOR FORCE. In the early period of Limoneira's development, there were no female employees, probably because the ranch was miles from town and there were no proper accommodations. For working with the fruit and in the orchards, the labor force was primarily Japanese men who were very adept at hand labor. Here the crew is sorting lemons.

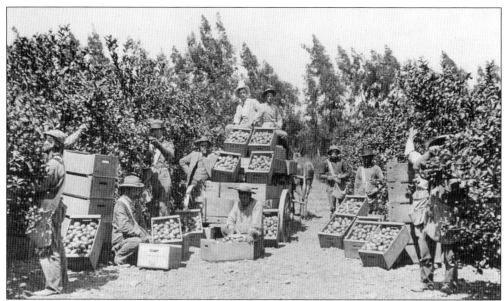

LIMONEIRA PICKING, C. 1895. This crew reflects the makeup of men employed as pickers. It was not until production increased dramatically after 1900 that it became an occupation held predominantly by a Mexican labor force. The canvas bags the men hung over their shoulders weighed around 75 pounds when full, and they were paid by the number of field boxes that were filled per day. The men in suits were passing foremen.

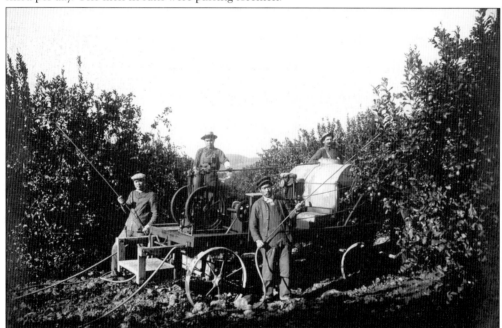

SPRAY RIG AND CREW. A variety of voracious insects regularly attacked citrus trees (and still do) and spraying with an emulsion of water and oil was an annual and tedious chore. Limoneira developed the first automatic oil spray rig around 1900, shown here, which mixed the two ingredients with compressed air. The rig consisted of a compressor, a tank, long hoses, and was pulled by mule team.

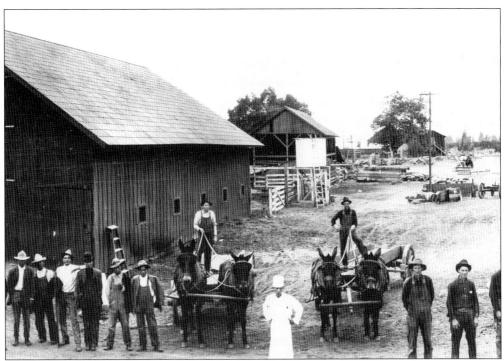

NOONTIME AT THE LIMONEIRA. After the dinner break, even the Chinese cook paused to pose.

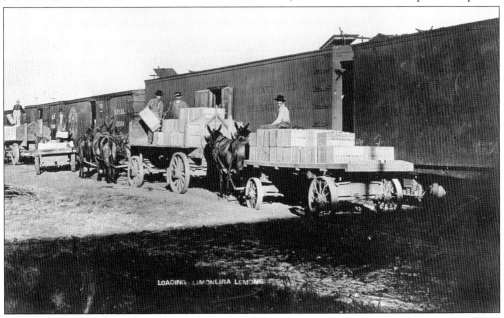

ALL ABOARD, C. 1895. To better accommodate Limoneira's expanding production, Southern Pacific put a spur line to the ranch's packinghouses. Pictured here are the well-ventilated, ice-refrigerated boxcars that were introduced in the 1890s and assured safe rail shipment. By the 1920s, so many thousands of acres were in groves that Santa Paula was supporting five additional packing plants. Due to the carload tonnage being shipped, it attained the enviable title, "citrus capital of the world."

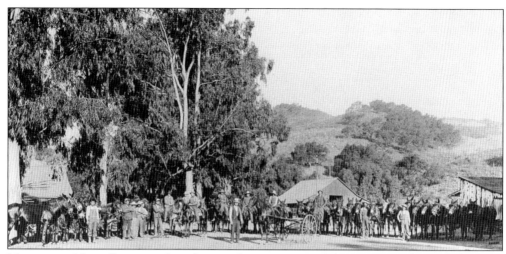

MULES AND MULE SKINNERS. Lined up are the teamsters and their teams in the yard where the huge barns and stables are still maintained by the Limoneira Ranch. Mules were preferred for their strength and smarts and were used until the 1950s, when machines became universal. The mule skinners had to be skilled in handling stock, expert at driving teams of six and eight animals across, and typically hailed from Missouri, where they learned their trade early. The teamster's daily grind began before dawn when he fed, curried, and harnessed his animals. After breakfast, he cleaned out the stalls, walked the team to the fields, hitched them to the equipment, and worked until dusk. Both men and animals were dog-tired by nightfall.

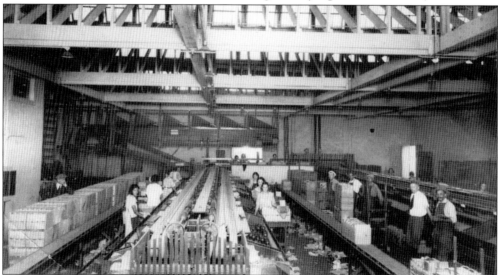

MUPU PACKINGHOUSE, C. 1920S. Typical of the packinghouses in Santa Paula by this time, the clerestory windows allowed natural light to flood the workplace. Mechanization had replaced much of the handwork, but women continued to be the main workforce. Each house was owned and maintained by its own association of growers. Today's high-tech equipment, computers, and improved safety standards are the design changes; cheaper, lighter cardboard cartons with printed, one-color identifications are the mode. Through the 1950s, the primary citrus crop was oranges—navels and Valencias. Oranges are no longer profitable, so the remaining packinghouses handle lemons, almost exclusively. Since lemons are harvested nearly all year long, the remaining packinghouses continue to be major employers.

Three

OIL!

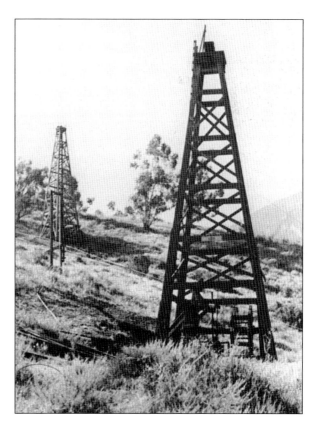

AT LAST, SUCCESS. Thomas Bard's Ojai No. 06 was California's first oil well to attain a production level that was sustainable at 15 to 20 barrels a day. Located just north of Sulphur Mountain, the Wildcat Well came in during 1866. It was but an inkling of what was to come for both he and an industry in infancy.

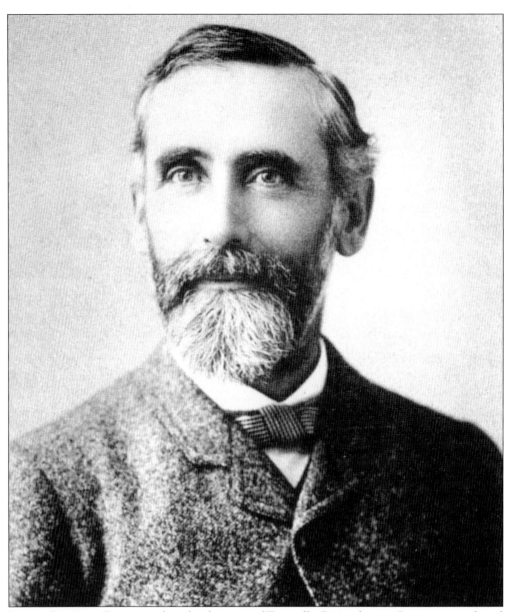

LYMAN STEWART. Born near the oil-rich region of Titusville, Pennsylvania, Stewart was infected with the black gold fever early and never recovered. Through the raucous years of the 1860s and 1870s, he learned everything about this new business, from working on rigs to buying and selling leases. He made and lost his share of fortunes, too. It was in the Pennsylvania oil fields that he happened to meet Wallace Hardison, a curious novice to the burgeoning industry. At the time, Stewart was broke, but Hardison was flush with money and opportunities were great. They formed a partnership on a handshake that pooled their resources of Stewart's vast experiences and Hardison's available capital. Slight of build, dapper in dress, and mild in manner, Stewart was the antithesis of his younger partner who was robust, daring, and gregarious. Their ultimate Hardison and Stewart Oil Company would be the foundation of the Union Oil Company of California. Although Stewart always maintained his residency in Los Angeles, he regularly visited the Santa Paula holdings by train.

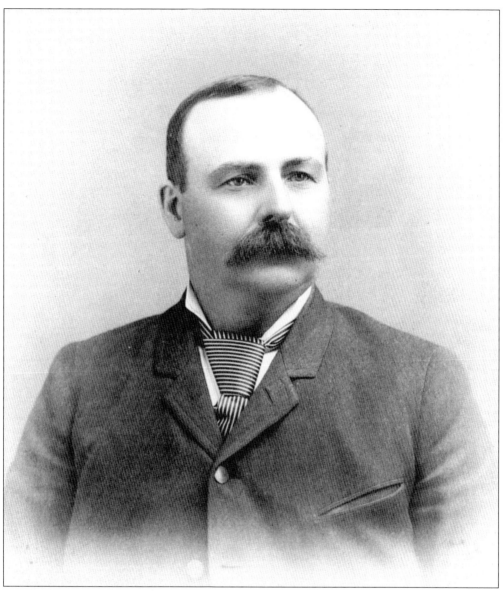

WALLACE LIBBEY HARDISON. A native of Maine, Hardison was born to a family who lived comfortably. Ever the wanderlust and entrepreneur, he met Lyman Stewart upon his return from Oregon, where he had profited from investments in timber. En route home, he stopped by Titusville to visit two older brothers who were working for Stewart. Intrigued by the booming excitement, they joined forces and together their activities paid off handsomely. However, the oil-field successes also attracted the great wealth of John D. Rockefeller, who, through purchases and manipulations, was monopolizing all aspects of the business. The "little guys" were being driven out, and the two partners split their fortune and went their separate ways. Stewart came on to California to investigate the potential oil lands being promoted, and Hardison went to Kansas and purchased thousands of acres for a cattle ranch. Impressed and encouraged by the oil activity he saw in northern Los Angeles County, Stewart wired Hardison to come west and bring drilling crews and rigs with him. Without question, he came in 1882.

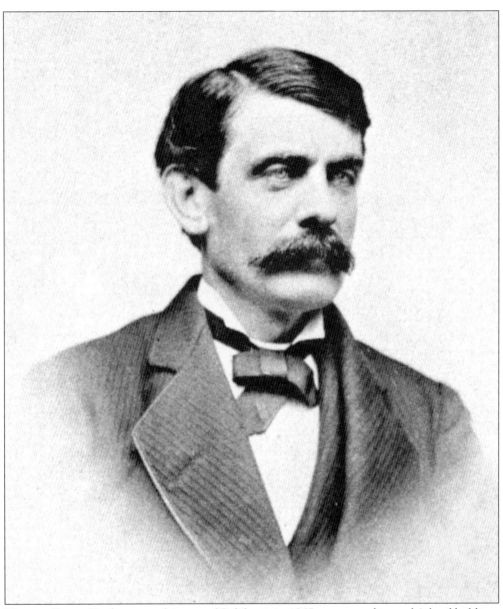

THOMAS BARD. Bard came to this part of California in 1865 to manage his uncle's land holdings and investigate the glowing reports about the region's oil potential. He was instrumental in bringing in the area's original oil well in 1866. Later, due to his uncanny business acumen and land investments, he emerged as the wealthiest man in Ventura County and resided comfortably in Hueneme. Though Bard flirted with oil during the 1870s, he turned his attentions to land development. In the meantime, the wildcatting oil company of Hardison and Stewart was enduring seven years of dry holes, or "dusters," and financial hardships. Even though they had purchased the Mission Transfer Company and were operating its refinery in Santa Paula, they could not produce enough oil to make a profit. Realizing they desperately needed an infusion of capital just to stay afloat, they approached Bard. Accepting their proposal to invest the necessary funds, the men organized two more companies: Sespe and Torrey Canyon. Bard's wealth would be the linchpin in the incorporation of the Union Oil Company of California.

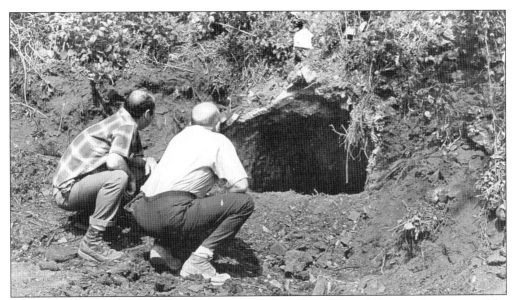

PEERING INTO THE PAST. Modern oilmen look into a collapsed tunnel their predecessors used for "mining" oil in to the asphalt-oozing Sulphur Mountain. It was because the slope's topography of sheer cliffs and thick oak woodlands that traditional drilling was impossible. Timbered tunnels as deep as 1,500 feet were dug in to tap the oil-bearing strata. The oil flowed out by gravity into storage tanks and continued to produce for over a century.

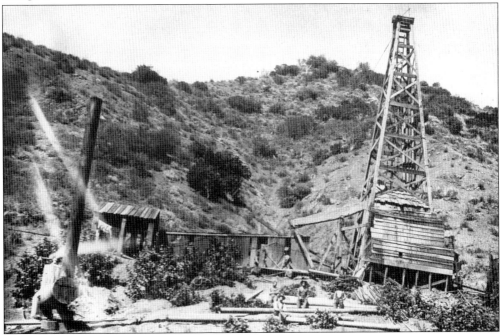

TRADITIONAL RIG, C. 1885. This Hardison and Stewart drilling operation was on Tar Creek in Sespe Canyon. The tableau showing the necessary essentials were, from left to right, a spare coal-burning steam boiler, pipe and casing on the ground, a crew, and a wooden derrick with casing hanging from cables. Not visible is the working boiler inside the covered shed between derrick and the men's cabin—complete with wash flapping in the breeze.

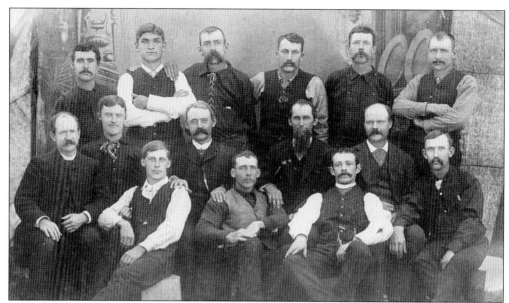

THE DRILLERS, 1884. They came with Stewart or Hardison from the Pennsylvania fields. Experienced, qualified and proud, the drillers were the highest paid employees in the field and the envy of their underlings. They drew a salary of $4 for a 12-hour tour (pronounced as "tower"), and they operated their rig with just one helper, the tool dresser. Among these men was the one who brought in "Wild Bill" in the Adams Canyon field, California's first gusher in 1888. Such wells just "gushed" crude because crews lacked the technology to cap the flow. Most of the men were bachelors who enjoyed a Saturday night carouse of beers and cards. Nevertheless, those with families contributed greatly to "civilizing" the otherwise rowdy community. Pictured here, from left to right, are (first row) Thomas O. Toland, Charles Hazelton, Dick Whidden, Mr. Wiseman and Link Gilger; (second row) Frank Davis, C. N. Baker, John Irwin, and Louis Hardison; and (third row) Ed Daugherty, Ed McCray, John Millard, Dave Swartz, Orin Parker, and George Fleisher.

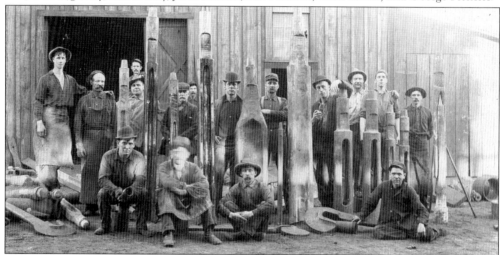

TOOLS AND BITS MAKERS, C. 1885. These were the men who hand-forged the heavy drilling equipment required to pound through the nearly impregnable geologic formations. Skilled smithies, if a driller required a specific tool they could manufacture it without plans. All they needed were the specifications and maybe a sketch scribbled on a scrap of paper.

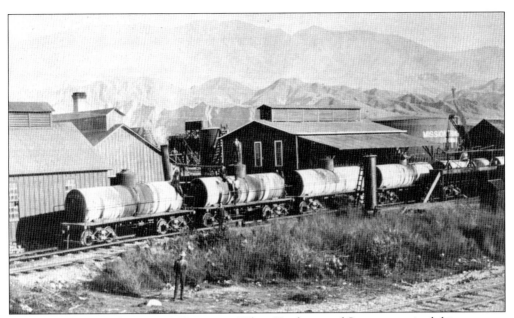

MISSION TRANSFER COMPANY'S REFINERY. When Hardison and Stewart acquired this company in 1886, it was their first acquisition. Since Mission Transfer also owned the mineral leases on Sulphur Mountain, along with pipes and pipelines, the purchase added substantially to the partner's assets and potential. The refinery was later absorbed and expanded by Union Oil.

KENTUCK CLAIM, SESPE CREEK C. 1887. This was one of the fields developed by the Sespe Oil Company, which was the first business created after Bard's initial infusion of capital. For his financial assistance, he was elected president. Joe Dye, a notorious local outlaw, with notches on his gun to prove it, had an interest in this claim, which created fodder for myth making.

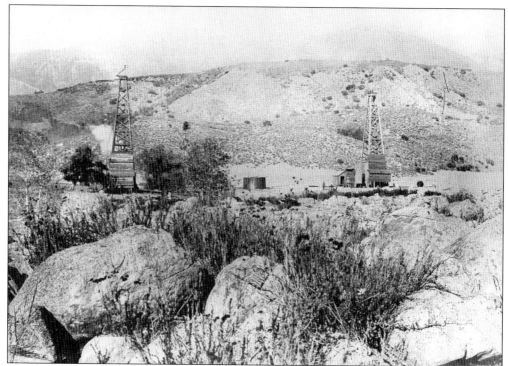

ADAMS CANYON FIELD. At the southern base of Sulphur Mountain was the site of California's first gusher, brought in by Hardison and Stewart in January 1888. The initial flow was around 800 barrels a day. It also produced sufficient natural gas to run all of the machinery in the field. For the crews, there was a dormitory with a dining room and cook, as well as having the town's first phone line that connected with Hardison's home.

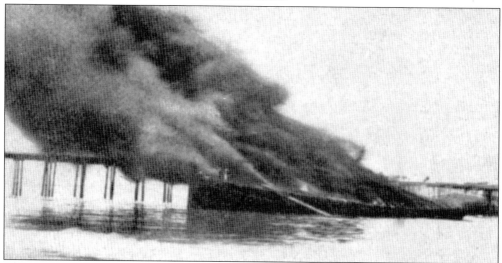

W. L. HARDISON BURNING, 1887. Attempting to force Southern Pacific to reduce their exorbitant rail rates, the inventive mind of Lyman Stewart designed a tanker to transport oil to the refinery in San Francisco. Although the ship operated but a few months before it burned at the wharf in Ventura, its appearance forced the railroad to reduce shipping costs. The ship was an industry first.

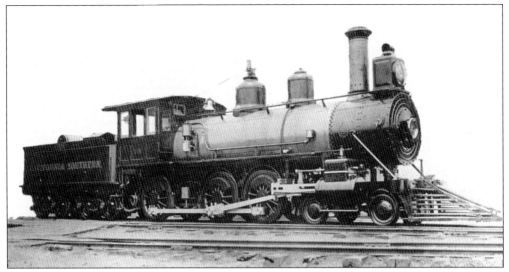

PULLING INTO HISTORY, 1888. Having developed a way to burn oil in their boilers, Mr. Stewart believed he and his mechanics could apply the same techniques to a coal-burning locomotive. After experimenting and tinkering in their Santa Paula shops, fine-tuning was done in San Bernardino. This engine was the sister of the one that pulled a string of cars over the Cajon Pass. It was another industry first by Hardison and Stewart.

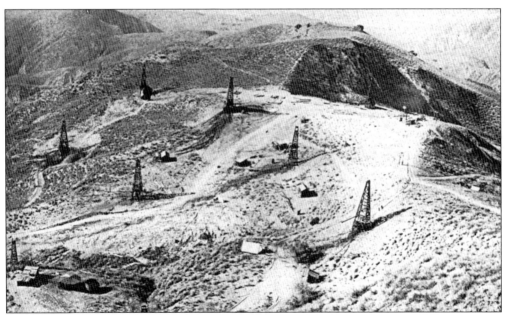

TORREY CANYON. In 1889, Bard again invested money and the Torrey Canyon Oil Company was organized. The field is located around 15 miles east of Santa Paula. The initial cable-tool rigs could only drill down around 3,000 feet, but with mechanized advancements and the development of the rotary bit in the 1930s wells drilled deeper and new technology prevented gushers. The field remains an important producer.

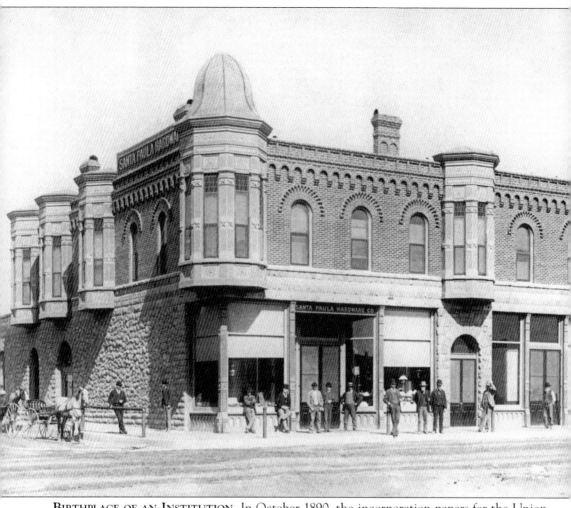

BIRTHPLACE OF AN INSTITUTION. In October 1890, the incorporation papers for the Union Oil Company of California were signed in the upstairs corner bay window by Hardison and Stewart, Mission Transfer, Sespe, and Torrey Canyon Oil Companies. The officers were president Thomas Bard, vice president Lyman Stewart, and treasurer Wallace Hardison. The company was capitalized with $5 million, just months before the men had been on the brink of financial ruin. An Eastern syndicate was ready to buy them out, which seemed their only escape from personal bankruptcies. Per the syndicate's instructions, they had completed an appraisal of their assets and were dumbfounded to learn their holdings were valued at over $1 million. When the syndicate withdrew, the men reevaluated their circumstances and voted to incorporate. Through the 1890s, the company stayed in Santa Paula. By 1900, there were major changes in the officers. Hardison had turned to citrus, Bard was a state senator, and Stewart was the company president. In 1901, he moved Union Oil's headquarters to downtown Los Angeles. Lyman Stewart was the only one who stayed with Union, and he guided it judiciously for the next 20 years.

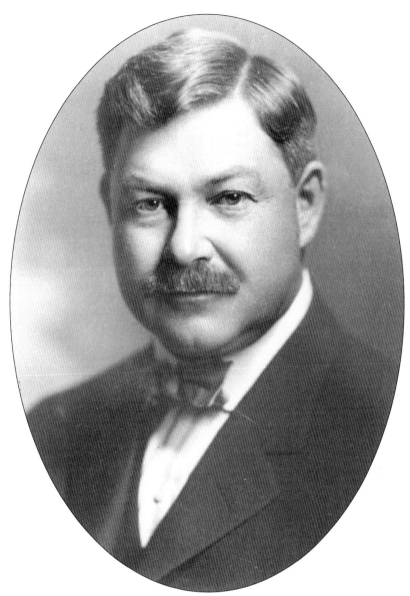

WILLIAM WARREN ORCUTT. Raised in Santa Paula, Orcutt graduated with the only class from the Santa Paula Academy and matriculated on to the new Leland Stanford Junior Farm (Stanford University). Majoring in civil and hydraulic engineering, with a minor in geology, he graduated with the pioneer class in 1895. Returning to his hometown, he married childhood sweetheart Mary Logan. Setting up shop as a civil and hydraulic engineer, partnering briefly with A. C. Hardison, he was hired by Union Oil in 1898. Dispatched to Coalinga to survey and lay a pipeline from its oil fields to tidewater, in his spare time he drew a topographical map of the broad Santa Maria basin. When completed, it was the first attempt to apply scientific knowledge with field observations in order to identify probable oil-well sites. Based upon his calculations, which proved most accurate, the company purchased or leased over 70,000 acres and Union Oil became a leading producer. He was summoned to move to Los Angeles to establish and lead the industry's first geology department in 1901. For his numerous contributions to the company and industry, Orcutt is considered the "dean of petroleum geology."

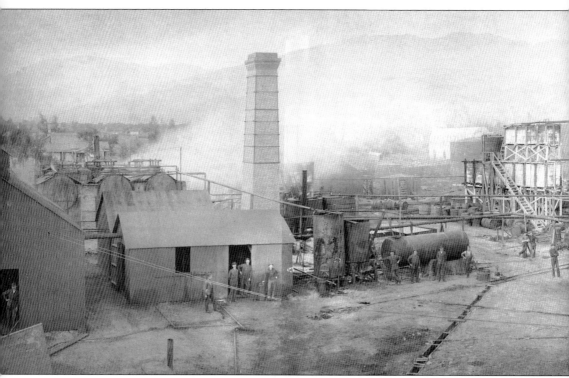

UNION OIL COMPANY'S REFINERY, C. 1891. The industrial complex was on the railroad tracks between Tenth and Eleventh Streets. It was a square block of throbbing racket, belching steam engines, roaring boilers, and pounding and grinding machinery that were associated with refining and manufacturing. The refinery, one of the few in California at the time, was making lubricating, illuminating, and fuel oils, gas distillates and asphaltum, which was used as a paving material. Gasoline was a product of the future. Located on this same parcel were the company's machine

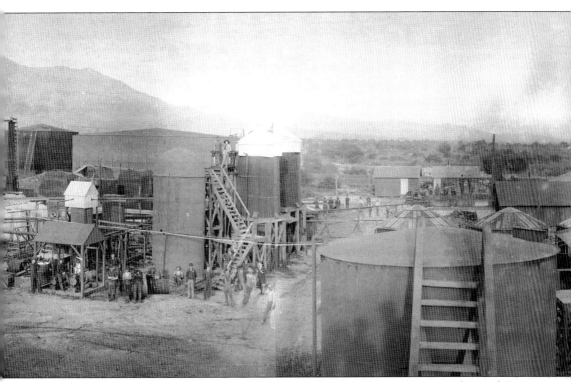

shops where drilling tools, boilers, tanks, and industry-related machinery was manufactured. In a separate building, lampblack was collected and used in the company's California Ink Factory laboratories. Here head chemist Dr. Frederick Salathe developed both a reliable printer's ink and other useful petroleum by-products. His employment with Union Oil was another first in the annals of the industry's history. The complex burned in a spectacular fire in 1897.

JACK LINE, SLOCUM FIELD, SULPHUR MOUNTAIN. This device was developed in the 1890s to pump a number of shallow wells in close proximity. The central source of power was the eccentric wheel that pulled the cables attached to each wellhead and thereby raised the oil in each well that was piped to storage tanks. Driven by a 25-horsepower engine, one of these innovations continues to operate in the area.

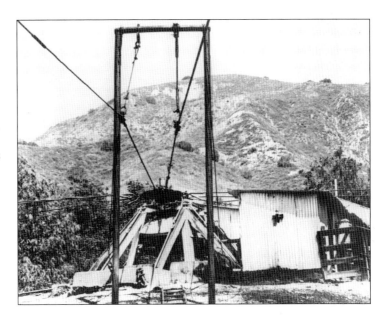

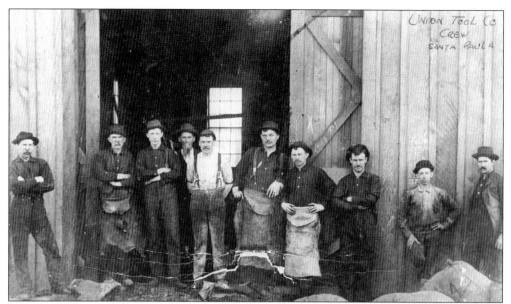

TOOL COMPANY, EXTERIOR. Union Oil needed an expanded tool manufacturing and repair complex primarily due to the chief geologist Orcutt's discoveries in Santa Maria. This demand resulted in the hiring of Ed Doble, who was a known tool-designing genius from Pennsylvania. He brought with him a crew of highly skilled oil-field machinists and blacksmiths, and together they formed the Union Tool Company. Leather-aproned Doble leans nonchalantly against the sliding door.

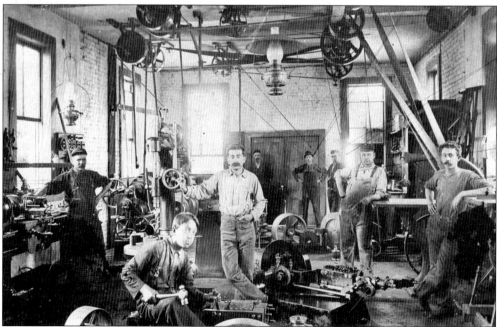

UNION TOOL COMPANY, INTERIOR. These were the machines, apparatuses, and conditions where the Union Tool Company's whiz kids forged their handwork. Pictured, from left to right, are (first row) Ralph Irwin; (second row) Fred Jones, unidentified, Ed Doble, and ? Waxsmith; and (third row) unidentified, Jim Conway, and Mel Harding.

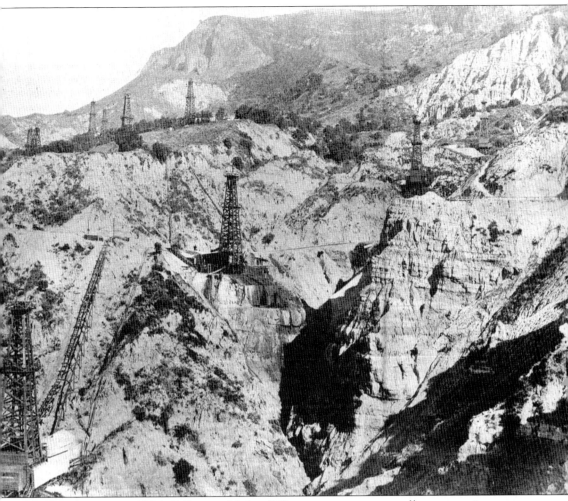

THE COMPETITION, 1924. Following Union Oil's successes, many smaller companies were grabbing up promising lands. One of the most successful was the Oak Ridge Oil Company. The field was located on South Mountain, the oil-rich area located across the valley from Sulphur Mountain. The discovery well, Santa Paula No. 01, is in the center, perched precariously. Note the tram rails. Such conveyances were used to transport crews or haul equipment to inaccessible wells.

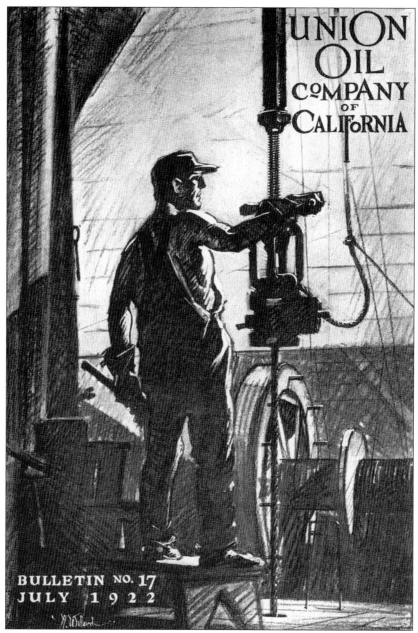

UNION
OIL
COMPANY
OF
CALIFORNIA

BULLETIN NO. 17
JULY 1922

LOOKING TO THE FUTURE. With his right hand resting easily on the temper screw and his left gripping a huge, heavy iron wrench, the driller stands facing the dawn of a new era—the petroleum age. His position on the rig floor was at the center of operations, and from it he controlled and directed all activities and assumed all responsibility for the well's ultimate success or failure. From the beginning of the oil business, the driller was the most important, most envied, and highest paid crewman in the field. There were no books to study and no schools to teach him his highly skilled job. He learned by observing, listening, experimenting, and training his senses to be acutely aware of every thing and every noise around him on the rig floor. That he was paramount to Union Oil's success is evident in this cover illustration of the company's in-house monthly publication.

Four

Their Main Street and Their Businesses

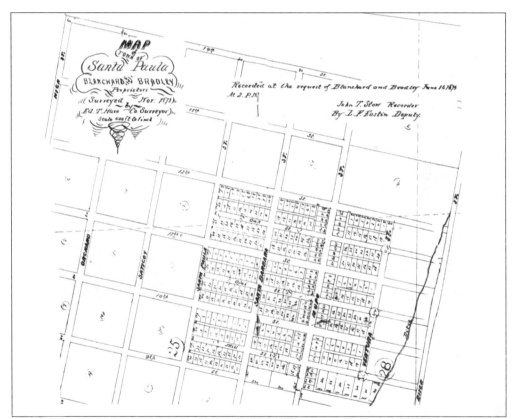

PLAT MAP, 1873. Although Santa Paula's official birth date was not recorded until June 1875, there were already 75 people calling it home when this survey was recorded. Along the single road were a collection of businesses: dry goods, blacksmith, furniture store, boardinghouse, schoolhouse, meeting hall, and the Pioneer Saloon intermingled with dwellings. Santa Paula was second only to San Buenaventura, the new county seat, in establishment and population.

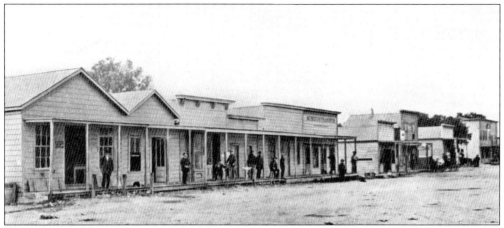

Mupu (later Main) Street, 1888. *Mupu* denotes the name of the Chumash Indian tribe who occupied the area for centuries. This photograph was taken looking southwesterly from about the intersection of Mupu and Mill Streets. The assortment of wooden buildings included a drugstore, the Mission Transfer Oil Company, a butcher shop, a post office/express agency, and a two-story general merchandise store.

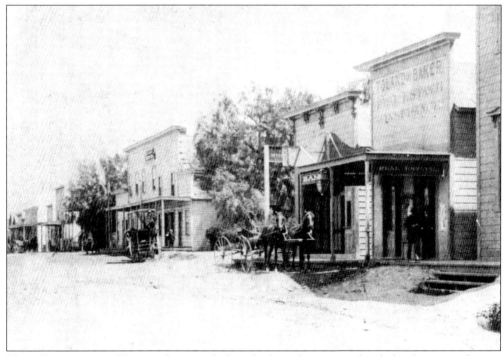

Main Street, 1888. This was the scene looking back up the street and includes the new real estate agency, indicating that the oil and citrus businesses were luring investors, residents, businessmen, farmers, and speculators. Santa Paula was up and coming. During the next decade, the town would reflect an image of permanence. Substantial commercial buildings replaced wooden ones, impressive Victorian homes appeared in tree-lined neighborhoods, and the population went from a few hundred to a 1,000.

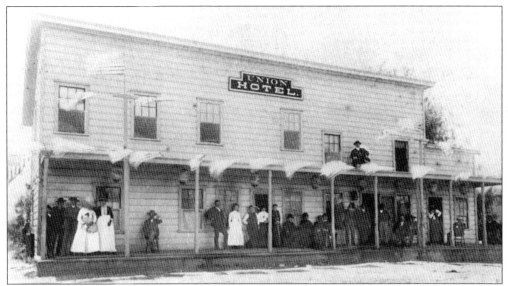

UNION HOTEL. C. N. Baker built this in the mid-1880s, and it was the town's first real hotel. Previously, visitors had to make do in makeshift lodgings. The Union offered 15 rooms, a dining room, and a separate bar and served a clientele arriving by the daily stagecoach. To celebrate the anticipated 1888 Fourth of July festivities, a parade and dance were put on, and the place was blazoned with bunting.

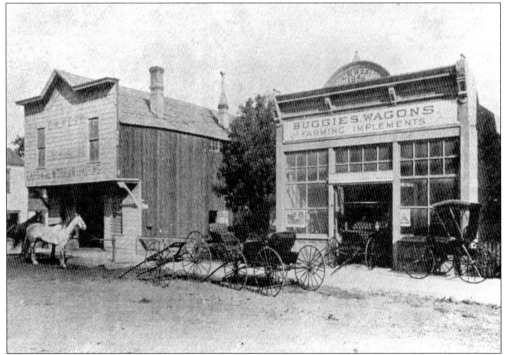

BASIC BUGGY DEALERSHIP. C. W. West had the corner on the conveyances market in 1885. The handsome building at right was his showroom for splendid buggies and farming machinery. The basic structure at left was used for repairs. A blacksmith by training and trade, later when the automobile pushed his merchandise off the road, West pushed east of town and went into farming.

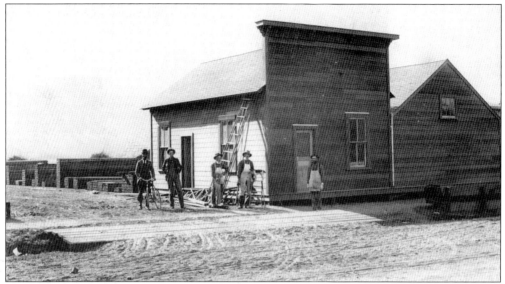

PEOPLE'S LUMBER COMPANY. Charles H. McKevett, a man who proved to be among the town's most influential and successful businessmen, organized this lumber business around 1888. Recognizing that the community's rapid growth demanded lumber, thousands of feet of raw pine were shipped from Puget Sound, unloaded at the wharfs at Ventura, freighted to Santa Paula by wagon, and finished at the planning mills.

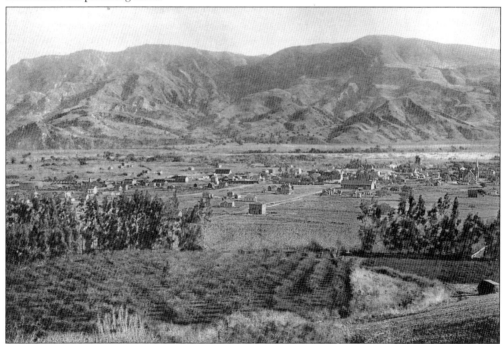

SANTA PAULA VIEW, MCKEVETT HILL LOOKING SOUTH, C. 1888. The arrival of the Southern Pacific's Branch Railway Company in 1887 brought instant travel and freight advantages for all concerned. The hill was so called because C. H. McKevett owned the property and his prominent residence was there. Close inspection reveals two trains, the Depot, the Southern Pacific Milling Company Building, and the towering spire of the Presbyterian Church.

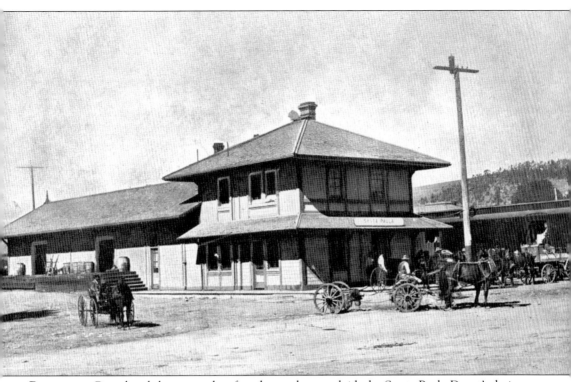

POSTCARD. Completed three months after the tracks were laid, the Santa Paula Depot's design reflects the anticipated freight, population, and need for an upstairs train-agent apartment. The railroad came through the valley and it indicated that the town was prospering and would be a regional center for citrus and oil shipments. After 1888, trains ran daily and locals used the regular scheduling for their advantages. Men fishing the Sespe flagged down a westward bound train and handed their bags of trout to the engineer with the understanding their wives would collect them at the depot. Enterprising boys bought oranges from growers for a penny a piece and hawked them to gawking tourists at two for a nickel or five for a dime. Even funeral processions had to be timed so as not to be caught crossing the tracks. The redwood structure came on flat cars from the company's shops in Sacramento. Delivered in prefabricated sections and painted the signature goldenrod yellow with brown trim, it remains the county's only depot intact and at its original location at 200 North Tenth Street.

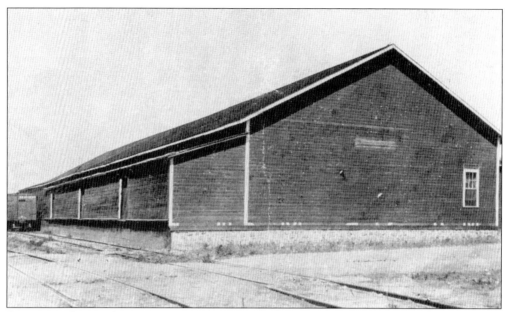

SOUTHERN PACIFIC MILLING COMPANY, 1888. As the destination for locally dried lima beans, apricots, and shelled walnuts, it was one in a chain of warehouses along the railroad financed by Santa Barbara investors. It was a commission business where such products were stored and sold when the price was right. For the farmers it guaranteed fair prices, while for the investors it guaranteed a good return on their money. It remains at 212 North Mill Street.

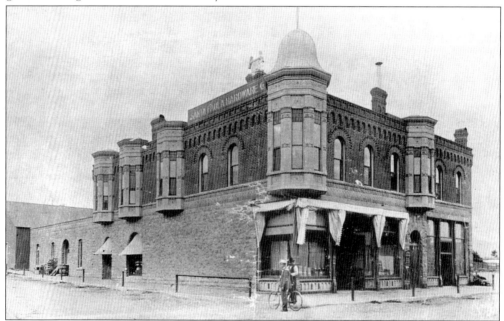

SANTA PAULA HARDWARE BUILDING, 1890. Main Street's first elaborate structure was constructed of locally fired brick, river rock, Sespe brownstone, and chiseled sandstone. The ground floor housed the hardware showroom and post office, and the second floor had offices and the boardroom for four local oil companies. The Hardison and Stewart Oil Company financed the building, and later that year it became the birthplace of the Union Oil Company of California.

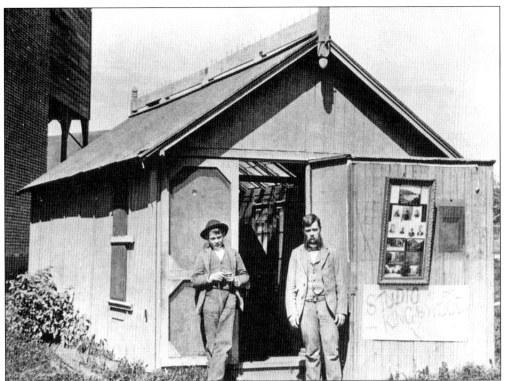

KING AND WOOD STUDIO. Next to Balcom Hall, the diminutive wooden studio provided the backdrops for dozens of portraits of local people. Later, King built a permanent structure on the property and started a thriving furniture business that was continued by his children. Pictured, here are ? Wood (left) and Charles E. King. Nothing is known of his cohort, but C. E. remained and left a rich visual legacy of early Santa Paula.

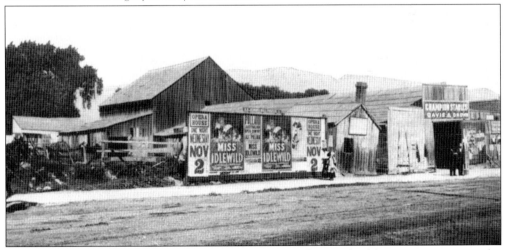

DAVIS AND DROWN'S CHAMPION STABLES, C. 1895. The ramshackle operation was on the north side of Main, between Tenth and Mill Streets, and was a favorite gathering place. Men sat around the office's potbelly stove where politics, jokes, and "remember when" discussions invited all comers to join in. "The ruins" were razed in 1913. Frank Davis had represented the interests of the Mission Transfer Oil Company.

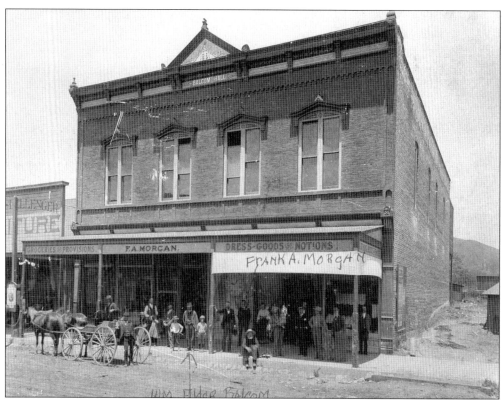

BALCOM HALL, 1891. This prominent building was at the center of Main Street. The store carried a variety of practical goods and the upstairs was the popular hall for dances, meetings, political gatherings, and other public functions. The structure was gutted by fire in the 1960s.

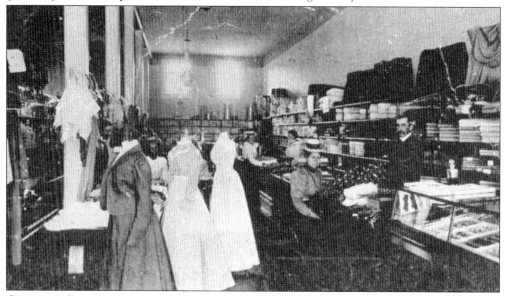

CROWELL'S DRY GOODS. Crowell, a pioneer merchant, stands behind the counter where he is showing a prospective customer a divine bolt of fabric. This was the ladies section; the gentlemen's department was adjoining. The building remains at 915 East Main Street.

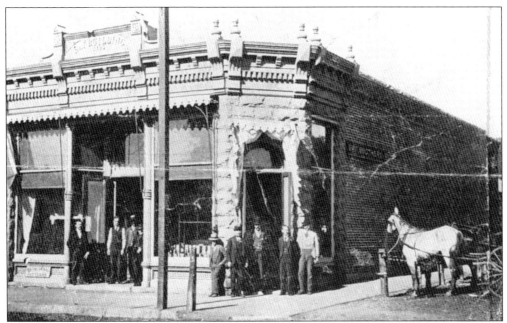

SAY BROTHERS STORE. Owners Norman and Harry Say built their brick building trimmed in Sespe brownstone on the corner of Main and Mill Streets and introduced the angled entry. They carried a variety of merchandise, as their advertisement indicated: "Dry goods, groceries, boots and shoes." As nephews of W. L. Hardison, they had an "in" with the oil boys. The structure is located at 949 East Main Street (in an altered state).

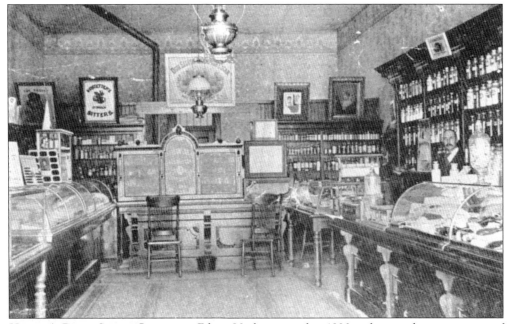

VIRDEN'S DRUG STORE, INTERIOR. Edwin Virden arrived in 1890 and set up shop in a corner of the Petrolia Hotel. Later, after moving into his own building (where he stands proudly behind the counter in this photograph), he ran a well-appointed and well-stocked pharmacy and operated his business into the mid-1920s.

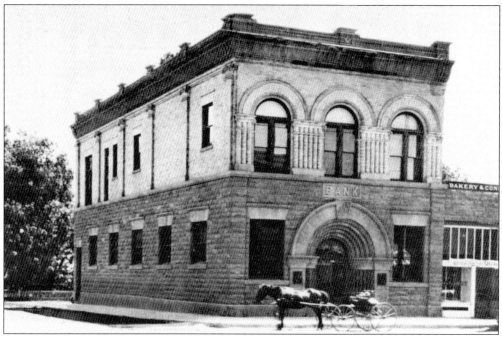

FIRST NATIONAL BANK OF SANTA PAULA, 1899. As the 1890s last major building, it was an institution organized by Charles H. McKevett in 1888 as the Bank of Santa Paula. Business and investments had grown with the town, and this substantial edifice was proof of its financial solvency and success. The ground floor was accented with Sespe Brownstone and being a Mason, he had the second floor especially designed to accommodate their lodge hall. The building is located at 948 East Main Street.

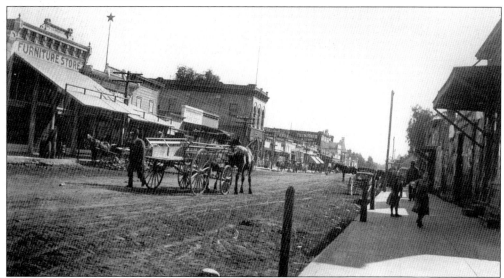

MAIN STREET, C. 1902. This photograph, looking west from around Tenth Street, shows a commercial district that is bustling with people, horses, and promise. Power lines, a telephone line, and paved sidewalks show that everything is up to date. The next year Santa Paula would incorporate and become the county's second city, behind Ventura of course. (To fit on their printed schedule, railroad officials shortened the name from San Buenaventura).

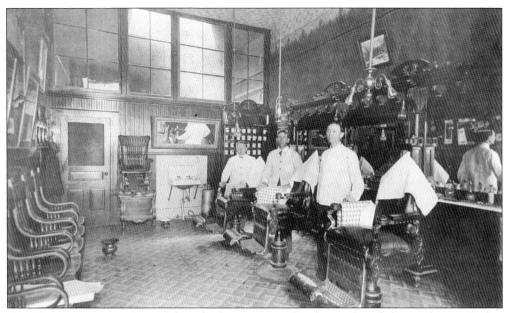

THE EMBLEM BARBER SHOP. These barbers, waiting for clients, from left to right, are Walter Wren, Joe Walters, and proprietor William A. Greenough.

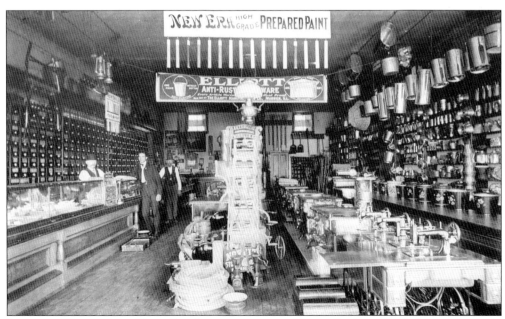

BUTCHER HARDWARE. Harry Butcher was a native of Santa Paula, as his father was an early harness-maker in town. In addition to running the business for many years, he also served as a county supervisor. The owner, with the derby, stands behind the counter at 861 East Main Street.

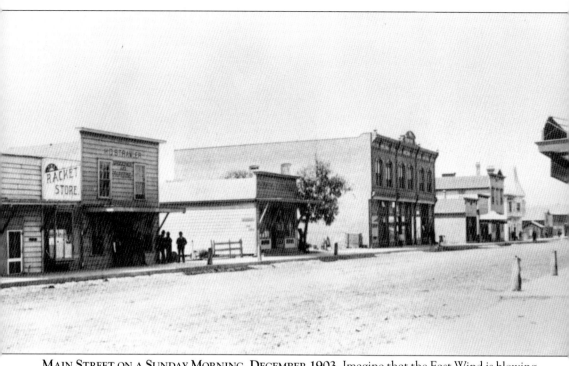

MAIN STREET ON A SUNDAY MORNING, DECEMBER 1903. Imagine that the East Wind is blowing gale-force winds and wild fires are burning in the hills—Santa Paula is a tinderbox. Around midnight, the night watchmen spot flames in that small wooden building just beyond the two-story, brick Goldstone block. He fires his gun and yells, Fire!" But there is no fire department, only the men rousted from sleep that formed a bucket brigade. Their frantic effort is no avail. The roaring wind carries flames and cinders westerly and across Main Street, and all wooden structures along the street are leveled.

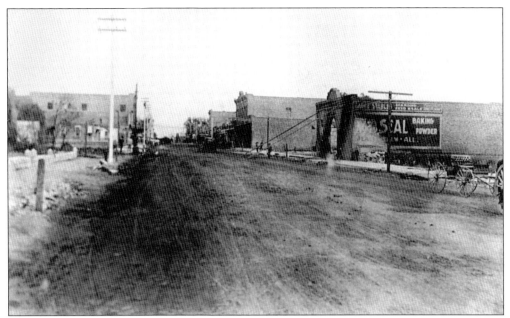

THE NEXT MORNING. A picture tells a thousand words. Gone are Cerf's Saloon, where the fire started, Cleveland Hall, Petrolia Hotel, and numerous smaller buildings and dwellings across the street, including city hall. No lives were lost, but official records, business investments, and personal life savings went up in smoke.

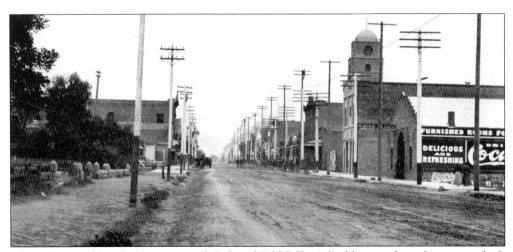

1905. Phoenix-like, the International Order of Odd Fellow's building, with its distinctive clock tower, rose out of Cleveland Hall's ashes. The city fathers created a commercial fire district requiring restrictive and explicit building codes and a volunteer fire department was organized. Never again did Main Street suffer such a disastrous conflagration.

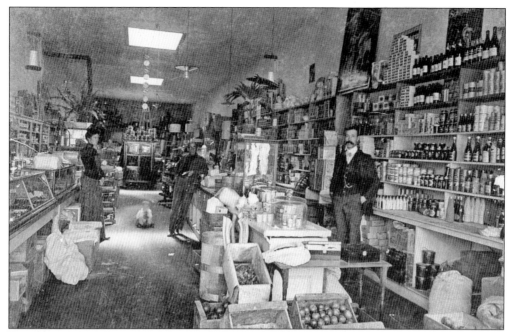

BROWN'S CASH GROCERY, INTERIOR. The dangling electric lights indicate the arrival of Santa Paula's own electricity-generating plant around 1902. Proprietor Brown stands by his well-stocked shelves. The displayed variety of fruits, vegetables, canned goods, and condiments speak well for business. Ike Brown introduced the concept of a cash-only operation.

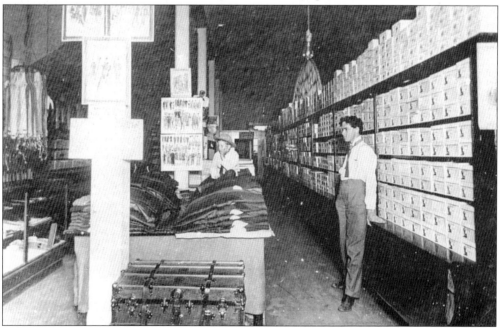

CASH DRY GOODS STORE. Owner Joseph Leavens and Britton Bowker took over Crowell's Dry Goods enterprise and operated their business for many years. They were successful because they imitated Brown's monetary strategy. The clerk and an unidentified onlooker await customers in the gentlemen's section. The building remains at 915 East Main Street.

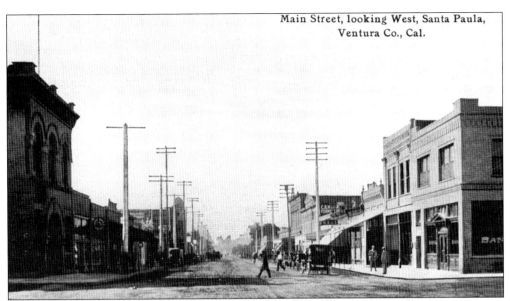

Main Street, looking West, Santa Paula, Ventura Co., Cal.

POST CARD, C. 1910. More electrical and phones lines now march along Main and not a horse is to be seen. The Say Brothers building has been transformed into the new financial institution of Farmer and Merchants Bank, in the right corner. Halfway down the street, at left, looms the Odd Fellows Clock tower. It was the street's prominent feature then, and remains so today.

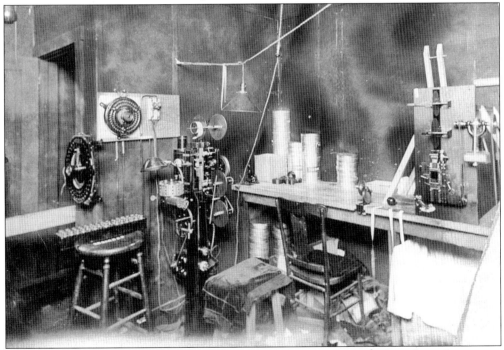

THE FLICKERS. From 1910 through 1916, Santa Paula was headquarters for independent movie companies Gaston Melies' Star Film Stock Company and Robards' Film Manufacturing Company, which bought out the former. Stars and crews traipsed around town and the countryside filming one- and two-reel Western thrillers and employing locals as extras. Pictured here is the editing room. The movie studio was located at the corner of Seventh and Main Streets.

IN REMEMBRANCE. Dean Hobbs Blanchard Memorial Library was the generous gift to Santa Paula from the N. W. Blanchard family in memory of their little boy. The $10,000 library was the cheered result of the male voters opting not to renew the city's last liquor license. The classically designed building opened with fanfare at Main and Eighth Streets and served as the community's culture center for the next 60 years.

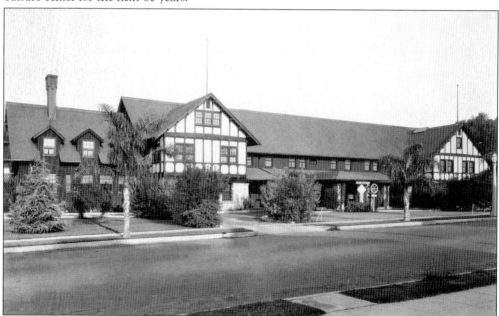

GLEN TAVERN HOTEL, 1911. Designed by Los Angeles's famed architectural firm of Hunt and Burns, the 32-room hotel, with dining room, was modern, commodious, and popular, especially among the train-traveling salesmen, businessmen, and entrepreneurs. Santa Paula was definitely the county's center for the oil and citrus industries, and the city was booming. Financed by local civic-minded investors, the elegant Tudor-style inn remains at 134 North Mill Street.

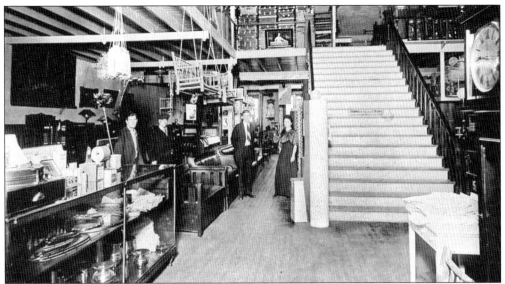

KING FURNITURE AND UNDERTAKING. C. E. King turned from photography to undertaking and then to furniture and furnishings and built this elegant two-story showroom at the same location as his original studio. Pictured here, from left to right, are Virgil King, C. E. King, Warren King, and Warren's wife, Grace.

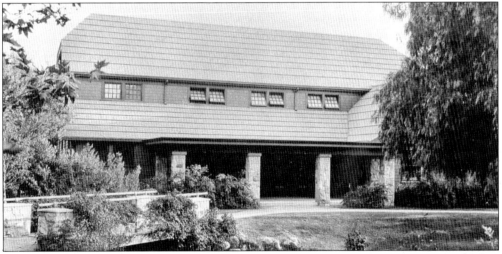

EBELL CLUBHOUSE, 1917. Alice Stowell McKevett gave the Craftsman building in memory of her husband Charles. The property had been the site of a movie studio. The Ebell is a national organization intended to bring cultural and educational programs to its female members, and Santa Paula's club was one of the first in California. The building was another Hunt and Burns design, and Mrs. McKevett spared no expense in the elegant clubhouse as appreciated in its full-stage auditorium, a smaller meeting room with a fireplace, and hardwood maple floors throughout. The extensive use of wood detailing and an open-beam ceiling further compliment the fine workmanship of the timeless architecture. The exterior is accented with hand-cut stone, cedar shingles, and a massive roof. The original grounds included redwoods, peppers, oaks, and pine trees with a reflecting pond full of colorful fish. Today the mature trees have been joined by new ones donated by the local rotary club. Currently, the building is the home of the Santa Paula Theater Center, so the original intent continues to be met. It is located at 125 South Seventh Street.

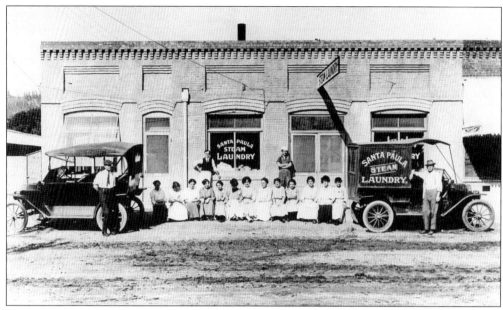

SANTA PAULA STEAM LAUNDRY, 1918. Among its most modern technologies included the centrifugal-force machine to spin clothes instead of the old-fashioned wringing process, which wreaked havoc on buttons and fabrics. Regular advertisements offered "family washes from 30¢ a dozen with the highest grade of hand work." The man in back wearing the vest was owner A. T. Ward. The building remains at 1150 East Main Street.

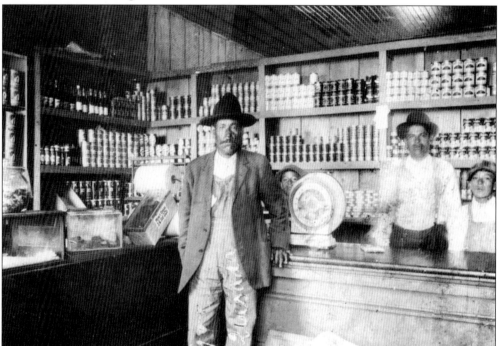

LOPEZ GROCERY. Said to be the first grocery to cater to the Mexican families, pictured, from left to right, are Jose Quezada, Selso Lopez, Faustino Lopez, the proprietor, and Jose Lopez. The boys were Faustino's sons, and they continued to operate the store for many years on North Tenth Street.

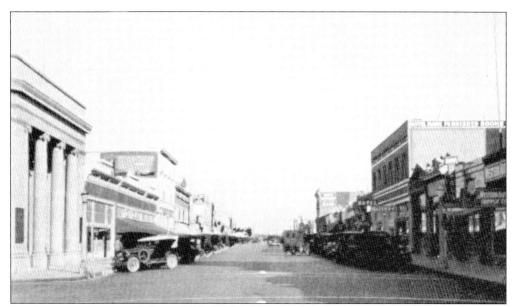

THE ROARING TWENTIES. Santa Paula recovers from the effects of World War I and the influenza epidemic, and gradually prosperity and health return. Main Street has been transformed and modernized. Gone are the power lines, which were moved to the alleys. The impressive Farmers and Merchants Bank, at left, set the tone for more new buildings to follow.

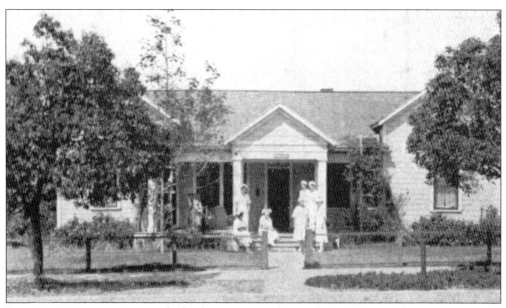

THE FIRST HOSPITAL, 1922. The birthrate was spiraling and a maternity facility was imperative. Located on Tenth Street, north of the alley, Cottage Hospital was owned and operated by Dr. and Mrs. Benjamin Merrill. The complex included the maternity wing, an accident ward with a separate emergency entrance, and the reception/waiting room in the center. What had been a rather small cottage was enlarged and converted into a spacious health-care center.

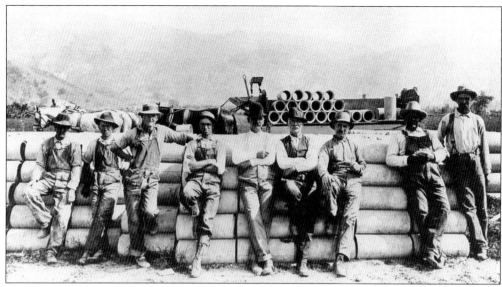

SANTA PAULA ROCK COMPANY AND CONCRETE PIPE WORKS. The operation was on River Street (Harvard Boulevard) for easy access to the riverbed aggregate. The electorate (that included women at this point) passed bonds for public improvements allowing the City of Santa Paula to authorize sewer and water lines and paved sidewalks throughout. Consequently, the stamped "Santa Paula Pipe Works" is still found around town. The owners, Ascension Vela and Ramon Prieto, appear fifth and sixth from the left.

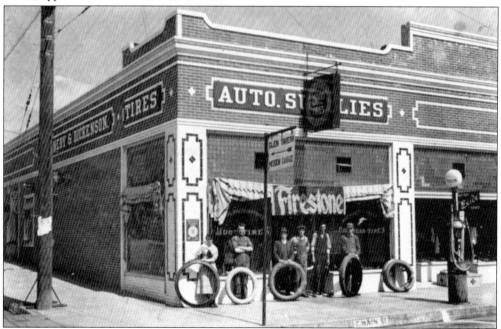

MONTGOMERY AND DICKENSON AUTO SUPPLIES. The advent of the automobile sparked a number of dealerships, tire stores, repairs shops, and mechanics in the city. The building's distinctive red- and white-glazed tile is still in evidence on Mill Street. Unfortunately, there are no other photographs reflecting these essential enterprises. Pictured, from left to right, are unidentified, unidentified, Lawrence Montgomery, Charles Mitchell, Ralph Dickenson, and unidentified.

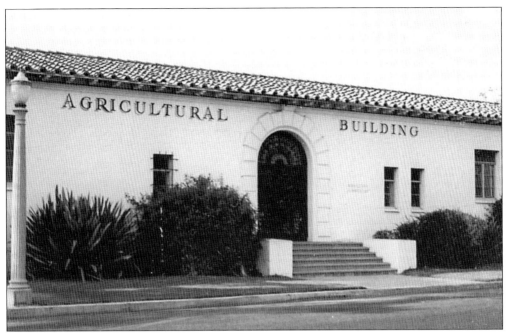

VENTURA COUNTY AGRICULTURAL BUILDING, POSTCARD. This building still serves as the offices and warehouse for the county agricultural commissioner. When built, the city's newspaper editor crowed, "It is yet another indication that we are considered the center of the county's agricultural interests." Roy C. Wilson Sr. was the architect of this structure that stands at 815 East Santa Barbara Street.

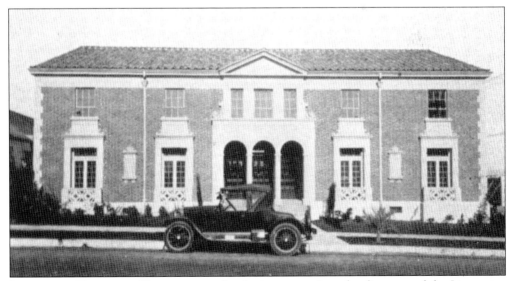

LIMONEIRA BUILDING. Twenty years after its incorporation, the directors of the Limoneira Company decided they had the wherewithal to build a modern, commodious, and impressive headquarters. The architect of this structure at 117 North Tenth Street was Roy C. Wilson Sr., who designed some of Main Street's most beautiful buildings that lent downtown a classy and enduring look.

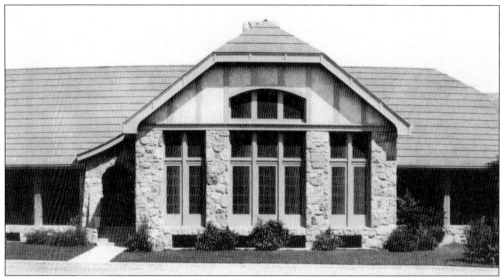

LIMONEIRA RANCH LIVING QUARTERS. Another Wilson design was this handsome structure used exclusively by male employees at 1141 Cummings Road. Pictured is the center section, which served as the gathering place before meals in the adjoining dining room with a second-story meeting/recreational hall. Underneath was a bowling alley. On either side was a pair of two-story dormitories with a 30-foot lap pool in between. Today it is the ranch's headquarters.

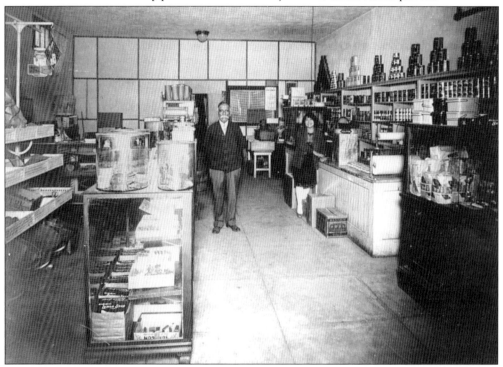

GARCIA'S GROCERY. The Limoneira Company built the extensive brick structure of small shops that still dominates the westerly corner of Main and Tenth Streets. It was presumably another Roy Wilson design. Francisco Garcia was one of the first occupants and is pictured here with his unidentified clerk.

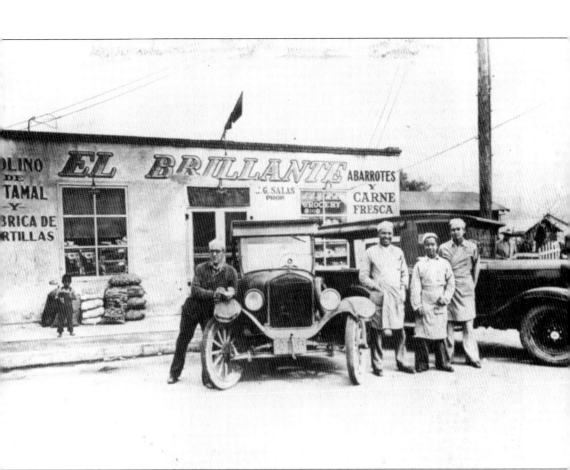

EL BRILLANTE MARKET. The substantial-looking grocery was located on South Ojai Street. Later, proprietor Juan Salas moved on to Main Street where the business continues to operate with his descendants and remains a brilliant landmark. Pictured here, from left to right, are Mike Cuccia, Salas, Joe Diaz, and Joe Preciado.

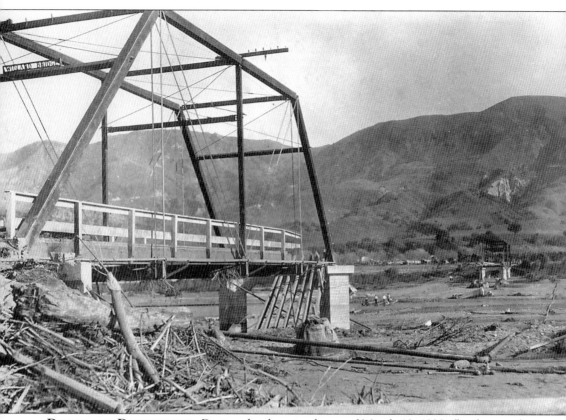

DEATH AND DESTRUCTION. During the dawning hours of March 13, 1928, floodwaters from the collapsed St. Francis Dam smashed into the lower section of Santa Paula and barreled down the valley, leaving death and destruction in it turbulent wake. So devastating, shocking, and unforgettable was the tragedy that for years it was the dating demarcation line. Events were identified as before or after the flood. Even though about one-third of the community suffered family losses and economic hardships, 100 percent of the citizens were affected. Today only faded photographs and aged gravestones are the grim reminders of the calamity, but for the remaining eyewitnesses and survivors, the memories remain.

Five

THEIR COMMUNITY
HOMES, CHURCHES, AND SCHOOLS

GEORGE M. RICHARDSON HOMESTEAD. Reminiscent of a country cottage, this was the first homestead south of the Santa Clara River. Richardson patented his quarter section in 1867. His sons enlarged the holdings and descendants continue to maintain the property.

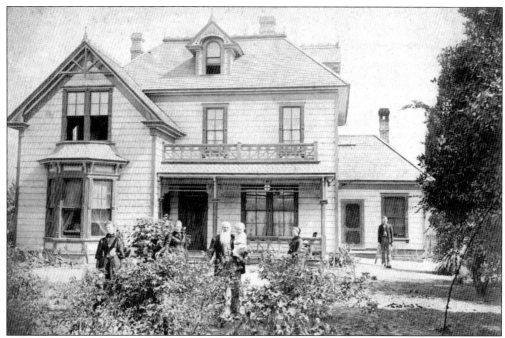

ABNER HAINES FARMSTEAD. Haines was among the men who had tried their luck in the gold fields before coming south to buy land in the Briggs subdivision. He purchased 200 acres in 1867. Pictured here, from left to right, are Edith Haines, Charlotte Haines, Abner Haines holding Ted Henderson, Maude Haines Henderson, and an unidentified man. The home is located at 14732 West Telegraph Road.

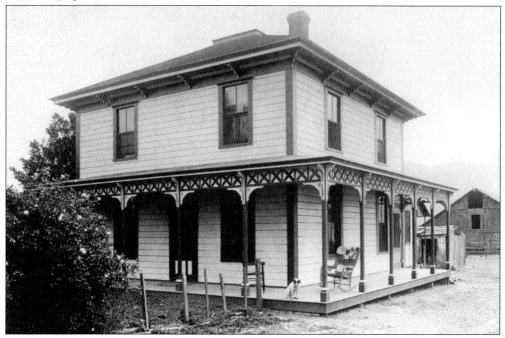

REUBEN ATMORE FARMSTEAD. Reuben's father, Richard, was one of many Atmore men who settled in the valley and was among the pioneering farmers to buy in the Briggs subdivision.

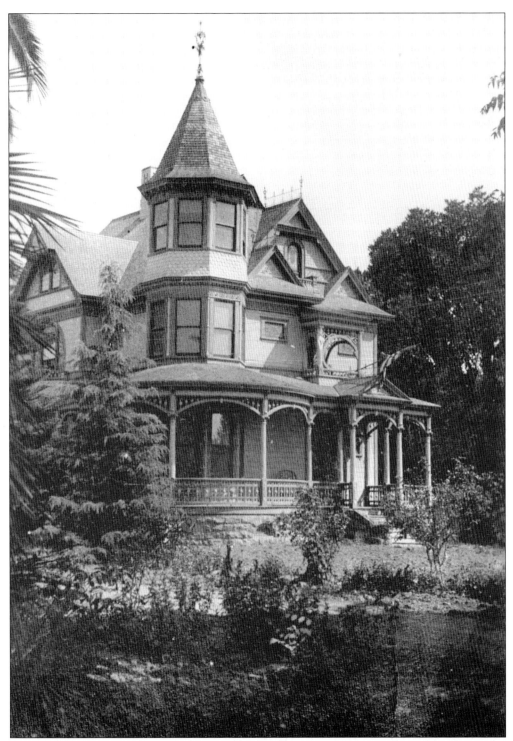

GEORGE WASHINGTON FAULKNER FARMSTEAD. Faulkner was also among the early settlers in the Briggs subdivision. A descendant once remarked, "The house wasn't much until they discovered oil on the place." The home is located at 14292 West Telegraph Road.

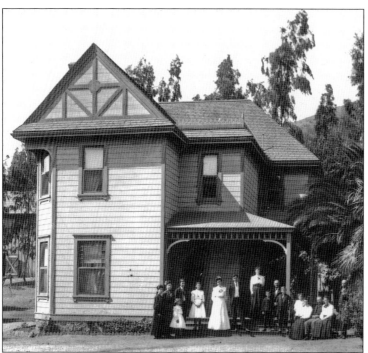

EDWARD WILSON WHITE FARMSTEAD. The ranch covered the lower and middle sections of Adams Canyon where White raised such dry-fanned crops as apricots, walnuts, pumpkins, and Hubbard squash. This photograph was taken in 1912 on the occasion of his daughter's wedding.

NATHAN WESTON BLANCHARD FARMSTEAD. Blanchard aptly named his place El Naranjal, "the place of the oranges." It was located at the upper end of Barkla (Palm) Avenue, just up from his packinghouse and just east of his citrus orchard. Note the immature eucalyptus in the background.

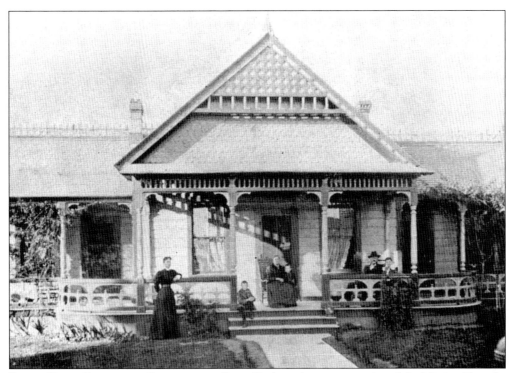

FRANK DAVIS RESIDENCE. Davis came to Santa Paula as the representative of the Mission Transfer Oil Company's interests. When Hardison and Stewart acquired it, Davis switched occupations to co-own and operate a notable stable, the Davis and Drown Livery, on Main Street. Davis had a street named in his honor and was elected to both the Santa Paula High School Board and the county board of supervisors.

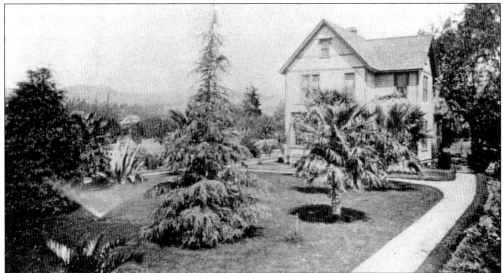

ALEXANDER WALDIE RESIDENCE. Waldie came from Pennsylvania with the oil contingency and continued to participate in their endeavors by serving first as secretary for the three oil companies and then as an incorporator for the Union Oil Company. He later was its auditor/bookkeeper. His "Waldie Dahlias" were famous across the county and always took honors.

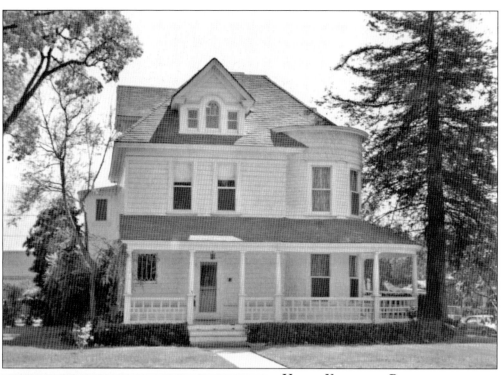

HARRY YOUNGKEN RESIDENCE.
Youngken was the first board secretary and manager of the Santa Paula Building and Loan, as well as being a member of the city council. Also the leader of the Santa Paula Concert Band, he was known to play a "mean" cornet. The home is located at 702 East Santa Paula Street.

ANDREW JACKSON BAKER RESIDENCE.
Jack, as he preferred, was the first city marshal and tax assessment officer. In his youth, he was quite fleet-of-foot and participated successfully in various races. The home is located at 525 East Main Street.

DR. DAVID WALLACE MOTT RESIDENCE. Dr. Mott maintained his office in a two-room apartment on the first floor and the family had their separate living quarters in the back and upstairs. Pictured here, from left to right, are the good doctor, his wife Emma, daughter Arley, and an unidentified man. The home was located on South Mill where the post office stands today.

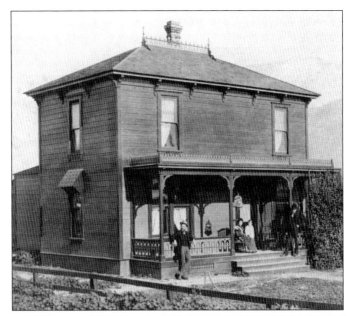

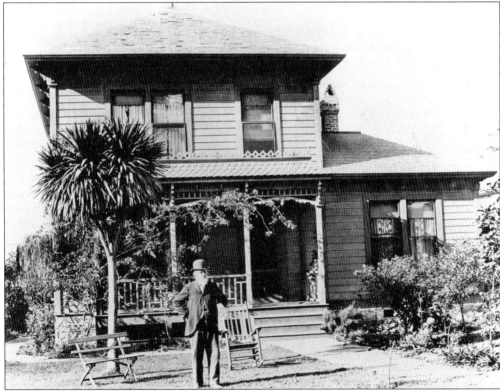

JOHN G. COREY RESIDENCE. An early resident, Corey's home was the center of cultural activities, scholarly readings, and community sings. Stirring literary discussions were enhanced with the boarding-school teachers whom his wife, Esther, welcomed. His position as postmaster furthered his popularity. That the public library was built on his property was most appropriate. The home remains at 126 North Eighth Street.

LOGAN RESIDENCE. Anna Mary Logan built the Logan home for herself and three children in the late 1880s. Local contractor Herman Anlauf erected the Queen Anne Victorian and, as was his habit for timely completion of payments, he awarded his client a complimentary fireplace. The hearth continues to compliment the parlor. Like most communities where original neighborhoods remain intact, a home is known not by the current occupant but by the initial owner. Pictured here in 1911 is the family that bought the house in the early 1900s and they are William and Amy Pearl Crawford with their children Pearl Bertie and William Jr. The residence stands at 123 North Mill Street.

CLARENCE RICE RESIDENCE. Rice was the co-owner of the Star Clothing store. The home was originally on Main Street, but was later moved when Eighth Street was extended. It was built with the first loan issued by the Santa Paula Building and Loan and was said to have the town's first built-in bath tub. It remains at 928 Yale Street.

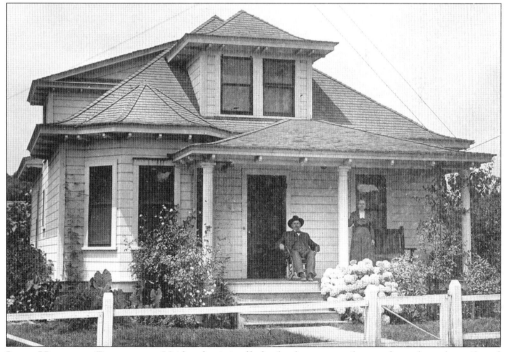

JOHN HARBARD RESIDENCE. Harbard originally had a farm east of town, but when the railroad cut it in two, it made farming very difficult. Later, the family moved into town and built this home. Pictured on the porch are Harbard and his wife, Sarah. The home is located at 130 Davis Street.

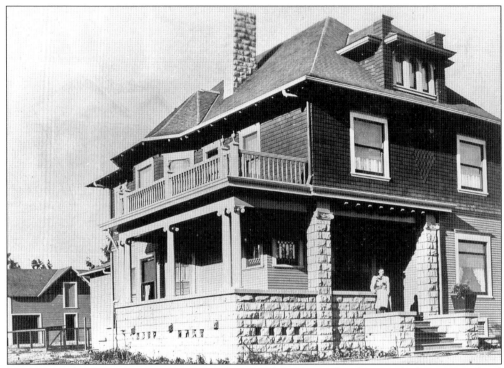

CHARLES COLLINS TEAGUE RESIDENCE. This was the Teague's first home, which was completed around 1903, a few years after his marriage to Harriet McKevett. At the time, Teague was in the beginnings of his lifelong involvement with the Limoneira Ranch. Pictured here are Mrs. Teague and daughter Alice. The couple also had two sons, Milton and Charles. Milton assumed his father's management of the Limoneira Company with similar successes, while Charles ably represented the local constituency in the U.S. House of Representatives for years. The home is located at 805 Santa Paula Street.

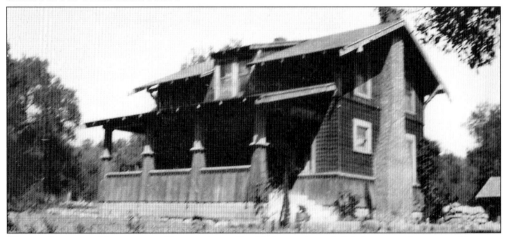

HARRY REDDICK RESIDENCE. City engineer Reddick purchased this home and surrounding two and a half acres in 1920 when the area was still quite remote. Just to the north lay the undeveloped Fern Oak Tract through which he designed the meandering roadways for the proposed subdivision. Today the neighborhood is called the Oaks and this photograph shows why. The home is located at 825 Ojai Road.

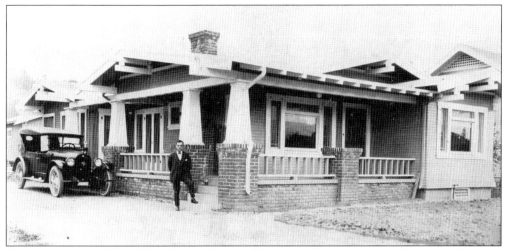

CHARLES ALBERT KING RESIDENCE. Presumably, this is King posing on the steps of his new home. The dwelling is an example of the planned-home concept that was introduced nationally in 1920 to ease the housing shortage. Promoted by the editor of the *Santa Paula Chronicle* and supported by the local builders and tradesmen, these pre-designed homes were pictured in newspaper advertisements and sold complete with plans and specifications. The home is located at 803 Pleasant Street.

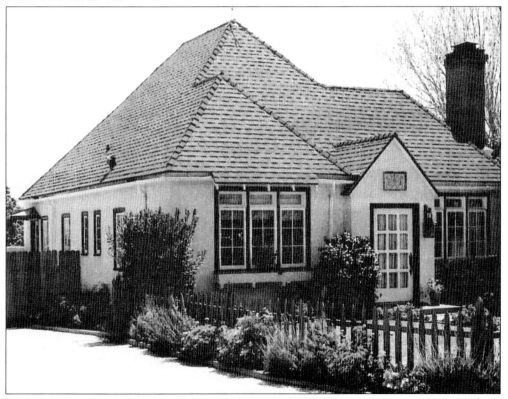

NICHOLAS DIEDRICH RESIDENCE. An early home in the McKevett subdivision, Nick Diedrich owned and operated the Automotive Replacement Parts on Main Street. The home is located at 924 McKevett Road.

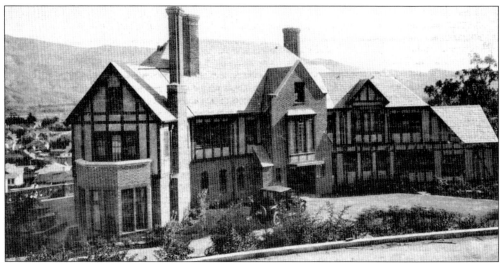

CHARLES COLLINS TEAGUE RESIDENCE. As a second family home, this residence has long been known as the Teague Mansion and was the first to be built in this section of the McKevett subdivision in early 1922. The hillside location was ideal to take advantage of the spectacular views up and down the valley. Baronial in scale and design, the architect was again Roy Wilson, who took great care to situate the residence to be compatible with the proposed three acres of grounds. The landscape firm of Ralph Cornell and Theodore Payne created the stunning setting with its sweeping lawns, decorative shrubs, and stately trees. Inviting steps from the spacious front terrace lead to welcoming garden paths. The formal interior with rich oak paneling, timbered ceilings, and spacious rooms lent itself to grand entertaining or intimate dinners. Teague was quoted as saying, "We love Santa Paula and the people, and we plan to live here the rest of our lives, so we built a house with that in thought." The home remained in the family until 1966 and is located at 724 McKevett Road.

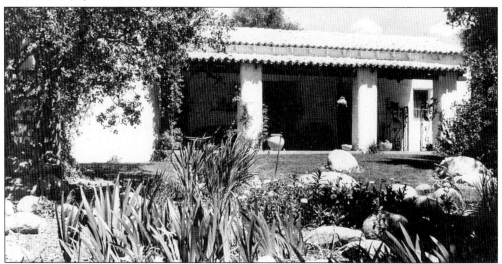

DOUGLAS SHIVELY RESIDENCE. Banker, self-taught artist, and architect, Shively was the longtime president of Citizens State Bank (First National Bank of Santa Paula building), which was started in the 1930s. Shively designed this house in the Mediterranean style, having been captivated by the architecture while serving in World War I. Completed in 1929, it was one of the first homes built on the Fern Oaks Tract of the Oaks neighborhood and remains at 1158 Woodland Drive.

THE FIRST CHURCH. Prior to Methodist-Episcopalians building this house of worship in 1883, the four denominations rotated their Sunday services in the schoolhouse. This simple wooden building cost the congregation $3,000 and stretched their coffers to pay it off. As a source of income, they rented their new sanctuary for $35 to both the Baptists and the Presbyterians for services.

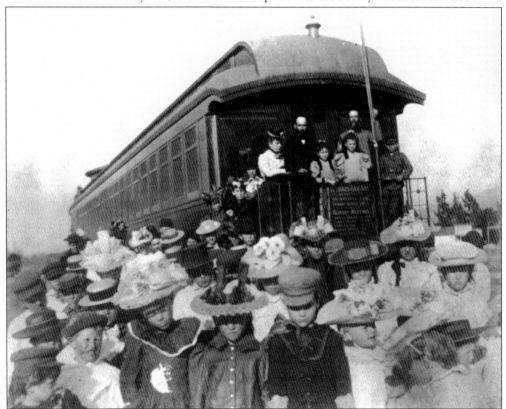

CHAPEL CAR, C. 1885. The idea of a church on wheels spread across on the nation's railroads. "Where will the church be tomorrow if there are no Sunday Schools today?" was the thinking that prompted the program. Sponsored by various Protestant faiths, the cars visited railroad towns that lacked a specific church. This train is bound for glory, and if a person rode, he or she must be holy. "This train, my Lord, this train" was a popular refrain heard throughout rural America.

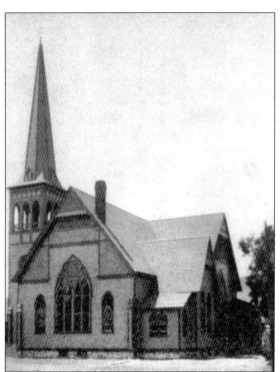

FIRST PRESBYTERIAN CHURCH, 1889. Originally sited on Main Street, this church's dizzyingly high steeple dominated downtown. The congregation raised $13,500 to build it and then struggled to pay off the remaining debt. In desperation, the parishioners voted to move the sanctuary to the back of their lot and sell the frontage piece.

ST. SEBASTIAN'S PARISH CHURCH, 1891. After the lot was acquired on the corner of Santa Paula and Ninth Streets, both Catholics and non-Catholics gave liberally to the building fund. The sanctuary was blessed in 1892. Because the front stairs were particularly steep, coffin-carrying pallbearers feared corpses could slip out of the caskets. Fortunately, such an incident never happened.

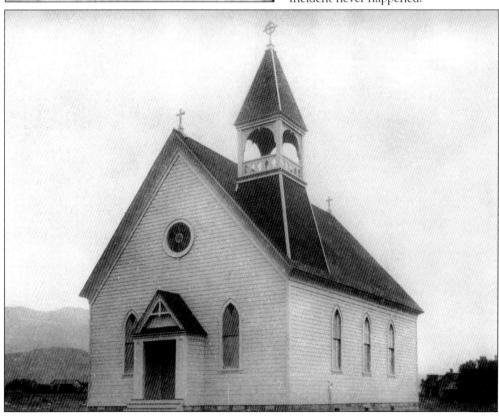

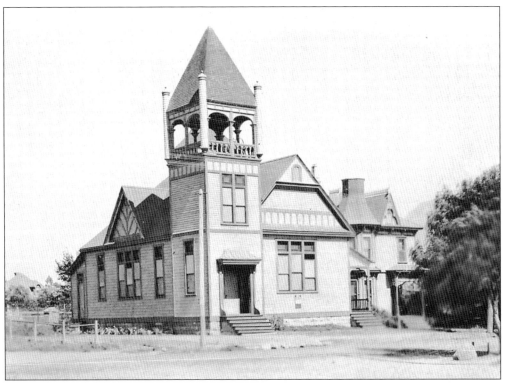

BETHEL BAPTIST CHURCH, 1892.
In 1888, a lot was purchased at
Mill and Santa Barbara Streets.
The church opened four years
later. Unfortunately, there is too
little history available for sound
researching of this church.

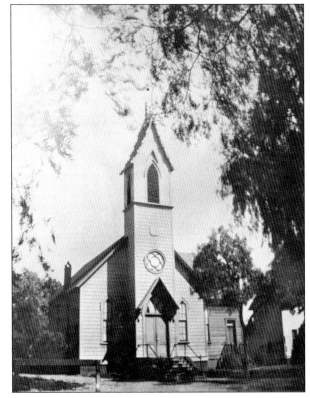

**ST. PAUL'S EPISCOPAL CHURCH,
1893.** The Reverend Walter H.
Marriott led the project to build
this church. Construction of the
building on Seventh Street, just
north of Main, commenced in
1892. Records show that the good
reverend contributed most of the
money and provided much of the
work. The total cost, including
some furnishings, was $1,500.

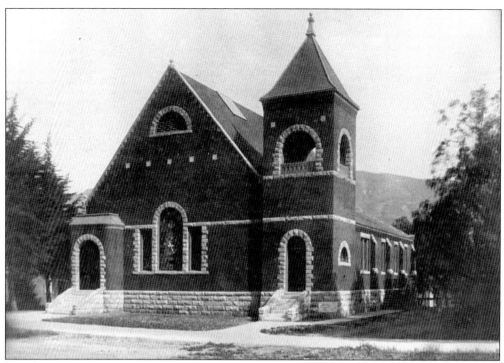

UNIVERSALIST CHURCH, 1892. The oil business brought out many Eastern families west, many who were Universalists. Among them was Wallace Hardison, who spearheaded the building committee. A lot on Main Street was purchased for $1,900 and the Pasadena firm of Roehig and Locke was hired to design the edifice. The splendid brick-and-stone church in the style of Richardsonian Romanesque cost $14,663. The church remains at 740 Main Street.

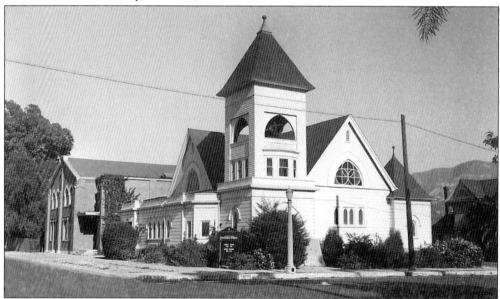

SECOND METHODIST CHURCH, C. 1900. Records indicate that this sanctuary was built sometime during the 1890s, but the cost is unknown. However, it was an impressive improvement, which must have greatly pleased the members.

FIRST CHRISTIAN CHURCH, 1900. Although the actual construction cost is not known, it was in the thousands based upon saved receipts. At the dedication, it was noted that a large sum of "love offerings" were donated to reduce the indebtedness. Its lovely stained-glass window was given in memory of Flora Stewart by her children. She was the wife of the founding minister, Rev. James Stewart. The church stands at 829 Railroad Avenue.

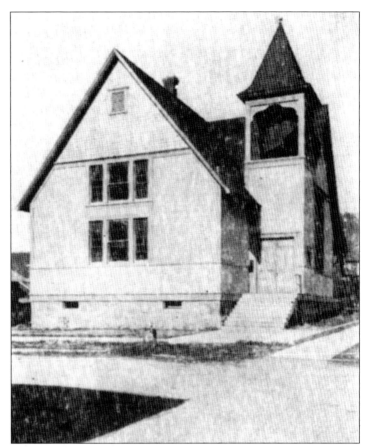

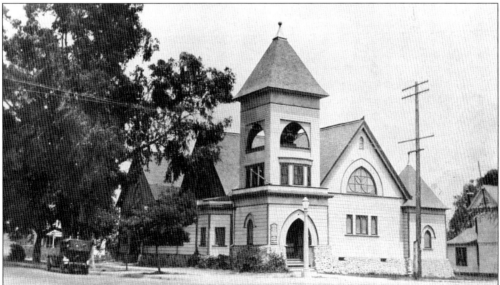

SECOND BAPTIST CHURCH. Like the Methodists, the Baptists had also improved and expanded their sanctuary considerably around 1900. As the parked card indicates, the photograph was taken some years later.

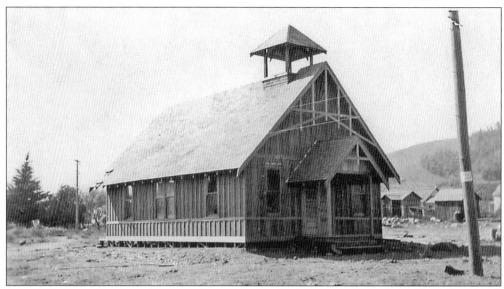

UNION SPANISH MISSION. The church resulted from the tragic murder of city marshal Norman in 1913 in a predominantly Mexican neighborhood. At the urging of Blanchard, the outraged community converted their anger into providing the area with its own church. Ministers and volunteers joined in the project, giving liberally of time, money, and materials. The chapel held its first service in 1915 in Spanish and continues today in a modern facility at 1029 East Santa Paula Street.

OFF TO SCHOOL, C. 1890. Getting to school involved riding, driving a buggy, or going by "Hank's mare"—the walking method. Whatever the mode, one toted a cold lunch packed in a used lard can. Classes began at 9:15 a.m. and ended at 3:30 a.m. Students learned the basic three "R's,"—reading, writing, and arithmetic—along with spelling, recitations, drawing, and calisthenics. In the Eighth grade an added course was "Instruction Against the Use of Alcohol and Tobacco."

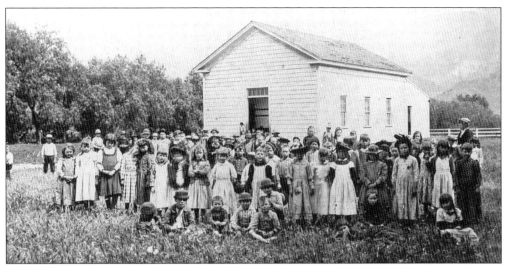

FIRST SCHOOL, 1874. Built with a $1,000 school bond, this school was located on the south side of Ventura Street between Mill and Tenth Streets. The redwood structure measured 26 feet by 40 feet and could accommodate up to 100 students. Professor Buckman taught all ages up to 14. The first year's students fit in easily. Yet by 1880, it was bursting, even with the added annex at the rear. Pre-church services were held here on Sundays on a rotation schedule.

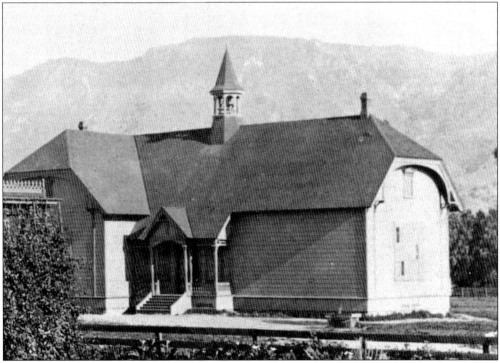

VENTURA STREET SCHOOL, 1883. A $5,000 bond financed this schoolhouse that was located across the way on the north side of Ventura Street. The two-room facility looked like a school, and with the 275-pound bell in the belfry it sounded like one. Thomas O. Toland was principal and teacher of the seventh and eighth grades, Anna Parsons taught the fourth, fifth, and sixth grades, and across the street Miss Shore had the lower grades in the first school.

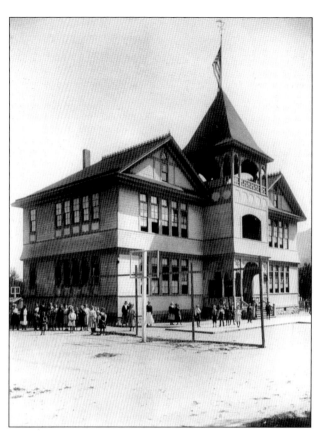

SOUTH GRAMMAR SCHOOL, 1898. When the population swelled to 1,500 with 500 being school-aged children, something had to be done. First, the "old" school was moved across the street and the "oldest" was torn down. Another bond led to this school being built and it was a beauty. The larger facility had six classrooms with a new staff of principal David Reese and teachers Carrie Fleisher, Jessie Clark, Jessie Todd, and Mr. Kyle.

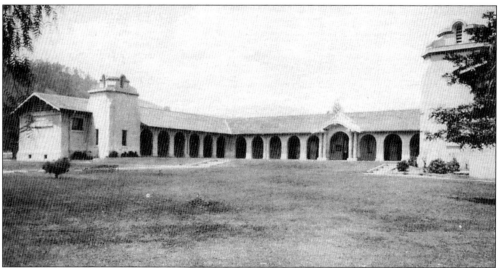

NORTH GRAMMAR SCHOOL COURTYARD, 1910. The ever-increasing number of children forced another bond, this time for $20,000. Located some blocks north of Main, the five-acre parcel was donated by Alice Stowell McKevett. Designed in the popular Mission Revival style, it had proper ventilation and heating systems, as well as indoor lavatories. Famed naturalist Theodore Payne supervised landscaping of native plants. In 1926, it was renamed McKevett and remains at 955 Pleasant Street.

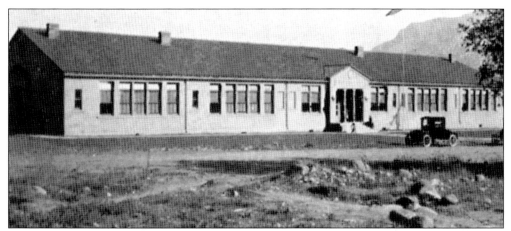

CANYON SCHOOL, 1925. Due to the dramatic increase of agricultural workers from Mexico, attention was given to non-English-speaking students with this school built in Spanish Town. At this time, students were segregated by fluency in English. For their parents, special classes in Spanish were offered in health, homemaking, and citizenship. Becoming Barbara Webster School in honor of the long-time principal, the facility remains at 1150 Saticoy Street.

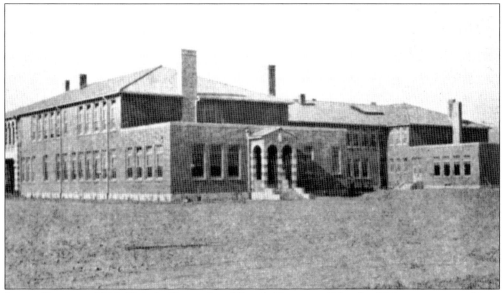

ISBELL SCHOOL, 1926. This facility replaced South Grammar School, which was converted into city hall. Built to accommodate the students south of Main Street from kindergarten through eighth grade, the older children experienced a departmentalized program in preparation for high school. The construction of the two new schools required bonds of nearly $50,000, and Roy Wilson Sr. designed both. Now only a middle school, the campus remains at 221 South Fourth Street.

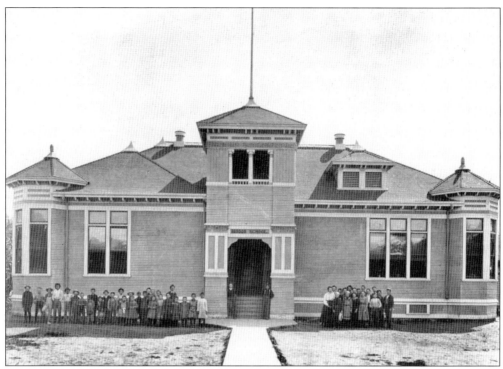

BRIGGS DISTRICT SCHOOL, C. 1910. A modern campus still serves students living west of Santa Paula in the old Briggs subdivision. The three remaining outlying elementary district schools feed into the Santa Paula Union High School. It is located at 14438 West Telegraph Road.

MUPU DISTRICT SCHOOL, C. 1914. Even though this photograph postdates the original school by some 30 years, it was the only one available. A newer plant continues to serve the students north of Santa Paula and is located at 4410 Ojai Road.

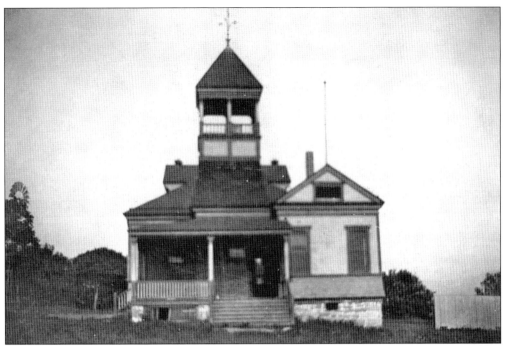

Santa Clara District School, 1907. Known locally as the "little red school house" because of its current color scheme, it was originally a battleship grey. The school is between Santa Paula and Fillmore and is one of the last two-room schoolhouses in California. It is located at 20030 East Telegraph Road.

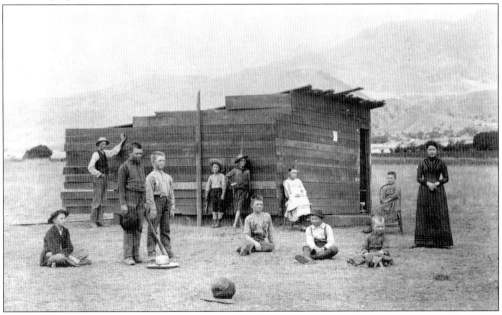

District School, c. 1870s. Slapdash for sure, this playground scene was captured at a location west of the future town of Fillmore. Its history is sketchy, but it could have been built by the homesteaders on a portion of the Rancho Sespe's disputed western boundary. Nonetheless, the schoolhouse had a teacher, students, and athletic equipment.

SANTA PAULA UNION HIGH SCHOOL, 1915. Hearing complaints that the heating apparatus was worn out, floors were worn through, and that rooms were too small, the board of trustees pleaded for the electorate to tear down the old building. The plea was heard and the $72,000 bond was approved. The school served the district until 1940.

SANTA PAULA ACADEMY, 1889–1891. This was the splendid building the new high school replaced. To the pioneers, proper schooling was paramount, but because education beyond the eighth grade was unavailable, the community agreed to finance their own secondary institution. Spearheaded by N. W. Blanchard, W. L. Hardison, and C. H. McKevett, a total of $17,000 was generated from the community. The private school offered courses of study in English, Science, and the Classics. That first year, five eager students climbed the stairs to higher education. In 1891, the academy was absorbed into the State of California's high-school system, but the building continued as the campus until 1915. Both institutions maintained an excellent reputation and graduates matriculated to prestigious four-year universities.

Six

THEIR
PLEASANT PASTIMES

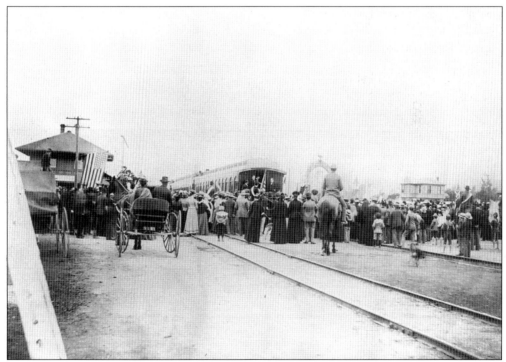

GREETING THE PRESIDENTIAL TRAIN, 1890. Benjamin Harrison's train stopped at the depot long enough to hear the cheers and for him to give a quick speech on the rear platform. Among the crowd was cashier Joseph R. Haugh, who had been his comrade-in-arms in the Civil War. The distinguished veteran turned president extended his hand with "Hello, Joe" and the retired major replied, "Glad to see you, Ben."

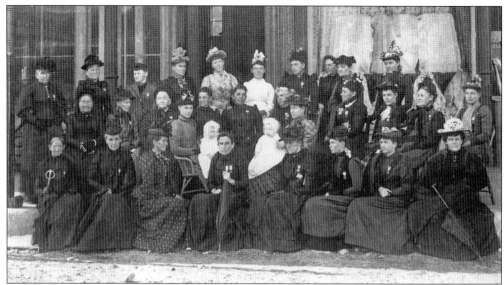

HELPING WHERE THEY CAN. The local chapter of the Women's Relief Corps (WRC) poses primly on Main Street. The WRC was a national organization dedicated to providing relief to disabled Civil War veterans, war widows, and orphans. They furthered their cause by placing special memorial plaques on veteran's graves in their local cemeteries on Memorial Day.

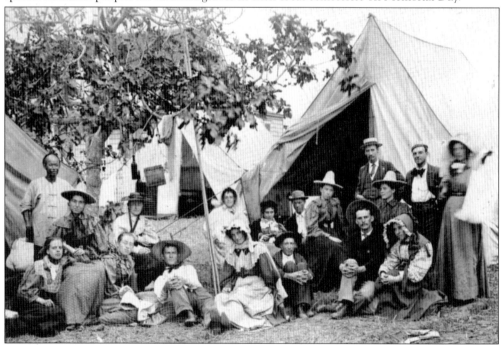

CAMPING AT SERENA BEACH, C. 1895. This popular spot was north of Carpinteria. Posing here, from left to right, are (first row) Madge Teague, Mrs. Clarence Beckley, Mrs. Puckett, Clarence Beckley, Mrs. Burrows, unidentified, and Charles Teague and his wife, Harriet; (second row) Mrs. Charles H. McKevett, unidentified, unidentified, Lafe Todd, Mrs. John Cauch, and Mrs. Frank Vale; and (third row) Who Flung Dung, the McKevett's house boy, John Cauch, Frank Vale, and unidentified.

STAYING AT THE SPRINGS. In the Santa Paula Canyon, near the confluence of the Santa Paula and Sisar Creeks, was this rustic but wonderful resort. Boasting a dining hall, a bowling alley, a plunge fed with curative sulphur waters, and a dance/recreation hall with live bands every weekend, it was a popular summertime spot. Some families had their own cabins, while others put up their tents, but everybody had a great time.

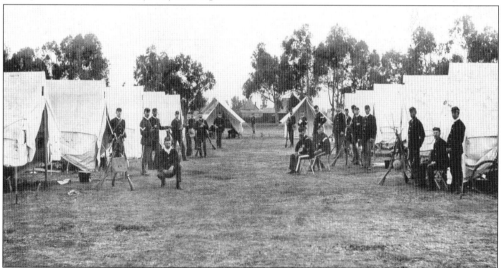

BEING IN THE GUARD. Santa Paula's Company E, 7th Regiment of the National Guard poses in an area just outside of town. It had been organized in the early 1890s under the command of company Capt. Charles Fernald. The men regularly drilled on Main Street, held target practice and marksmanship competitions, and learned basic combat skills. They were charged with protecting their community in the event of a natural catastrophe or an invasion.

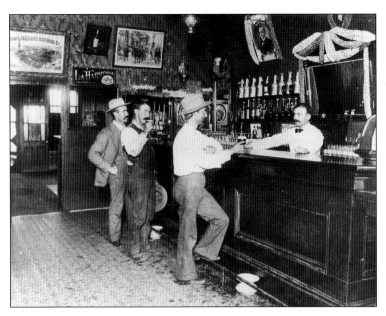

QUENCHIN' A POWERFUL THIRST. A Saturday night pastime for bachelor oilmen and teamsters was a cold beer with warm conviviality. These gentlemen are imbibing at Cerf's Saloon. The festooned photograph of President Harrison and the mirror hint of a Fourth of July celebration.

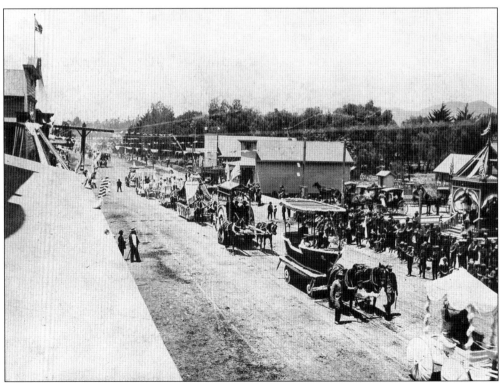

WATCHING THE PARADE, INDEPENDENCE DAY, 1898. Splendid floats decked out in red, white, blue, and Old Glory pass grandly along Main Street. The photograph was taken from a westerly view from around Davis Street. The large forested parcel in the background was private property whose ownership is unidentified.

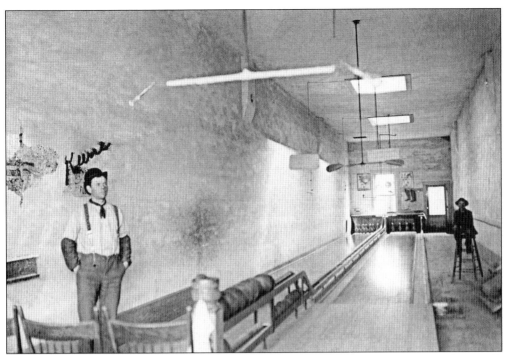

GETTING A STRIKE. The Main Street bowling alley belonged to Herman Keene, who stands proudly at left. It may have been primitive, but it was a welcome recreation indeed.

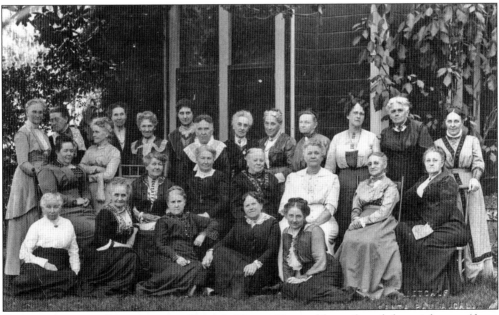

GATHERING FOR A LUNCHEON AT EMMA'S HOME. Pictured here, from left to right, are (front row) Brown, hostess Mott, Haugh, Carver, and Miss Blanchard; (second row) Clayberg, Fleisher, Andrews, Boor, Burrows, and Cummings (two of the ladies in this row were not identified and do not know which); and (third row) Hardison, Todd, Butcher, Ruggles, Parker, Miss Arley Mott, Irwin, Underwood, Procter, Faulkner, Davis, Clarke, and Peck.

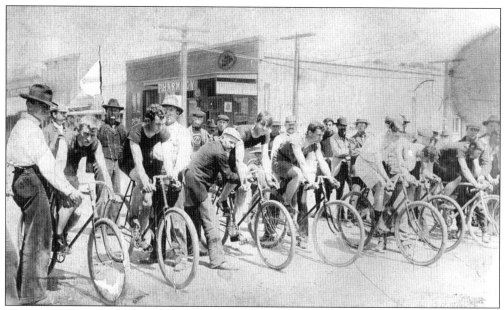

BEING IN A BIKE RACE. Be it horses, bicycles, or on foot, men enjoyed racing among themselves or in competition with other towns. The starting gate for this race was Mill Street before it went west on Main to Telegraph Road and on to five-points in Ventura before returning—about 25 miles. Money and good wishes were exchanged.

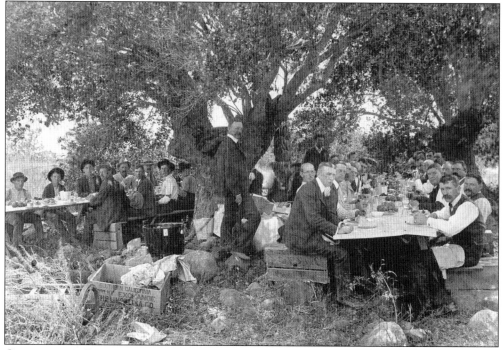

GOING TO AN INDEPENDENCE DAY BARBEQUE. The annual, all-male event was held at Bill Boosey's ranch east of town. The host poses in front of the sprawling oak tree. With plenty of good vittles, a hank of bananas hanging in the tree, or oranges on the tables for dessert, it looks a fine time was being had by all.

LAYING THE CORNERSTONE, MAY 1905. Members of the International Order of Odd Fellows, (IOOF) proudly pose in full regalia for this momentous occasion of their hall rising from the ashes of the 1903 Main Street fire. Established in 1888, it was the town's first fraternal organization. Standing, from left to right, are Charles Colbert, William Stein, George Nowak, Philip Newman, Mac Harvey, Ben Pressey, unidentified, and unidentified.

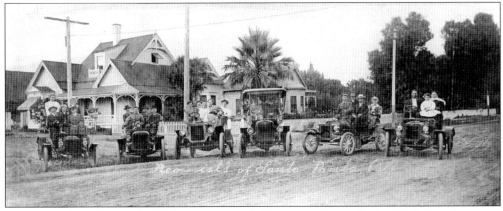

BEING IN A CAR CLUB, 1907. The caption reads, "Reo-ists of Santa Paula, Calif." in reference to their Reo automobiles. They paused on Main Street before taking off for parts unknown.

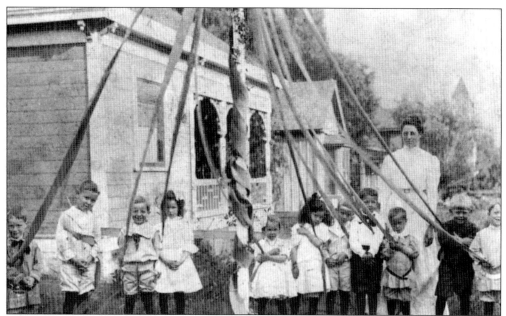

DANCING AROUND THE MAY POLE, 1907. The ribbon-clinging dancers, from left to right, are Milton league, Ernest Greppen, Walt Farrand, Charlotte Reese, Bernice Mahon, Freda Grant, Art Strong, Merrill Small, Kenneth Small, Lafe Brown, Willard Beckley, and the rather harried hostess, Alice Farrand (Mrs. George).

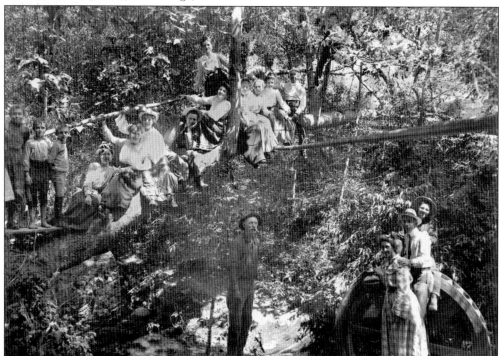

RELISHING A SUMMER'S DAY. Beaux, beauties, and betrothed gather at Mill Park. Clark Varner, the last miller, stands in the center while others frolic about the relics of the Santa Paula Flour Mill, which had burned in the late 1890s.

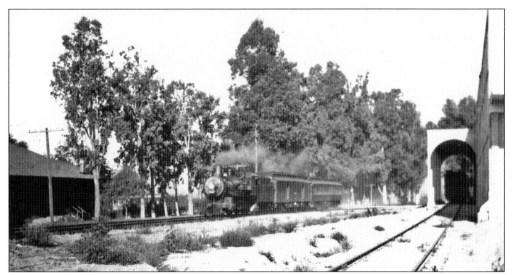

RIDING THE *GALLOPING GOOSE*. When Southern Pacific opened the more direct route, around 1907, Santa Paula went on the spur line. This two-car conveyance, freight, and passenger became the way to join the main line to go shopping in Los Angeles, go off to college, or go wherever. The origin of the uncomplimentary nickname is unknown, but it was a regular visitor to the depot for years. The photograph was taken in Fillmore.

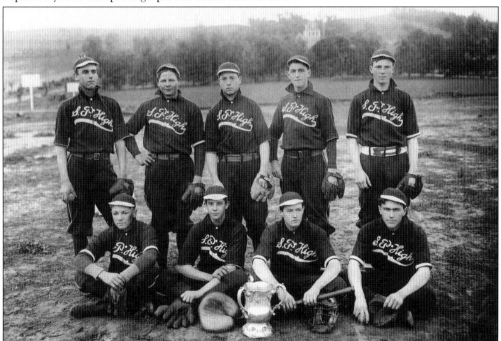

BEING ON THE WINNING TEAM, 1910. Posing for this photograph are the Channel Islands champions, having won 15 consecutive baseball games. They lost the regionals to Los Angeles High, 7 to 4. The young men, from left to right, are (first row) right fielder Syd Graham, left fielder Heathcut Munger, catcher Leon Pressey, and first baseman Art Smith; and (second row) pitcher John Munger, center fielder Joe Rafferty, shortstop Carroll Sharp, third baseman Bud Badger, and second baseman Leo Weber.

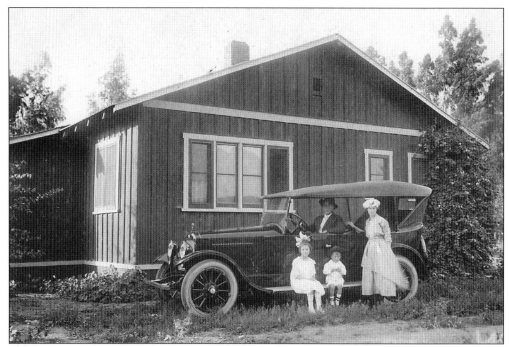

GOING TO CHURCH IN OUR SUNDAY BEST, C. 1911. At the steering wheel is Alvin Boles, the proud owner of this splendid automobile. At the time, he was the assistant manager of the Teague-McKevett Ranch. He later assumed a management position and held the rank for years. He poses with his two children, Bernice and Roger, and his wife, Attie. Behind them is their home on the ranch.

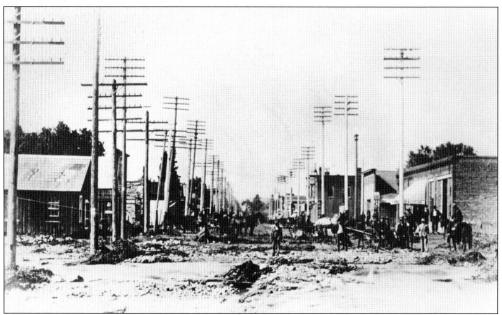

SURVIVING THE FLOOD OF 1914. This was the resulting rock and debris deposited at about Main and Eleventh Streets by the raging Santa Paula Creek. Damage appears minor, but the cleanup was major.

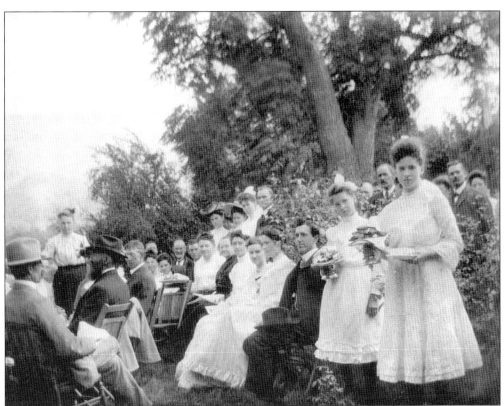

ENJOYING AN ICE CREAM SOCIAL.
This elegant affair was a fund-raising
occasion for the Methodist Church.

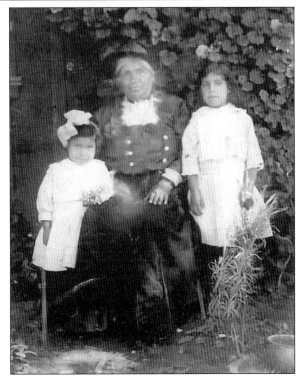

POSING WITH GRANDMOTHER.
Catarina Ramirez Lopez poses with
granddaughters Lydia and Andrea.

SHOWING OFF THEIR CALF.
Brothers Jose and Selso Lopez
pose with this bovine in 1915.

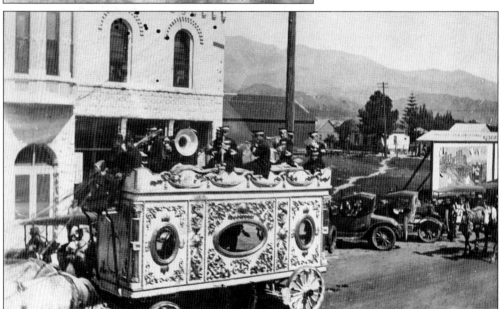

WATCHING THE CIRCUS PARADE, 1919. The glittering, noisy, and exciting two-mile-long parade announced the two-day Al G. Barnes Company's show-stopping spectacular. Advertising 1,200 animals, 200 people, 6 concert bands, 3 calliopes and so much more, it all arrived on the wonderful circus train. Under the big top was a four-ring spectacular of 103 sensational animal acts. The greatest show on earth had come to town.

GETTING MARRIED. Josefa and Jose Angel Diaz were married in the old St. Sebastian Church in 1919. In 1935, they opened "Las Quince Letras" at the corner of Eleventh Street and Harvard Boulevard. A year later, they moved to their current location at 249 South Tenth Street, where the restaurant became a dining institution that continues to thrive as "Familia Diaz."

POSING WITH THE IN-LAWS. Lucy Smith and Douglas Shively took their vows in September 1919. Shortly thereafter he was shipped over seas. The wedding party, from left right, are Tilley Shively, Ella Smith, the bride, the groom, A. L. Shively, Fred Smith, Gabrielle Halstead, Holly Halstead, and unidentified.

JULY 4, 1920. With bands, patriotic speeches, and airplanes circling above, thousands watched Harriet Willard christen the splendid bridge across the Santa Clara River. She led the motorcade over the span, which linked Santa Paula to the rich fields of South Mountain's Oak Ridge Oil Company. She was accorded such honors for her generous contribution that closed the gap of the massive fund-raising campaign for the bridge's construction.

PLAYING STICK BALL WITH THE FELLAS. These unidentified rookies play in the dirt street.

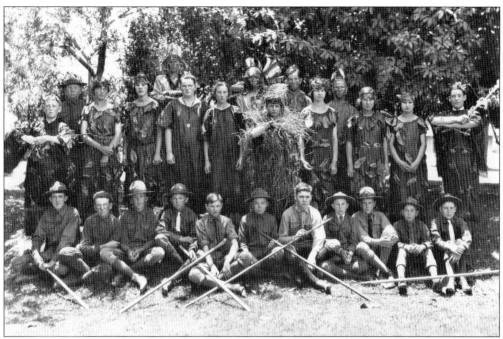

PARTAKING IN A HAPPENING, 1923. Boy Scouts with hoes and crowbars, girls and boys dressed in floral finery, and some young "natives" in war paint pause to be immortalized by the camera. Who they were, where they were, or what they were about is a mystery.

BLUSHING BRIDE. Rachel Gould, soon to be Mrs. John Bascom Taylor Jr., poses in her wedding gown.

SHARING A TIDBIT WITH HER CAT. India Belle Taylor and her beloved pet are captured in this photograph. Taylor lived to be 102 and attributed her longevity to "inheritance and to an inherent belief in God."

HANGING OUT. The three young men perched atop the car, from left to right, are brothers Jim and Frank Villa and their cousin Amador Rivas. Note that the radiator emblem proclaims their hometown.

PICKING BOWERS OF WILD FLOWERS. The Gould and Taylor families pose in front of a car after picking wild flowers.

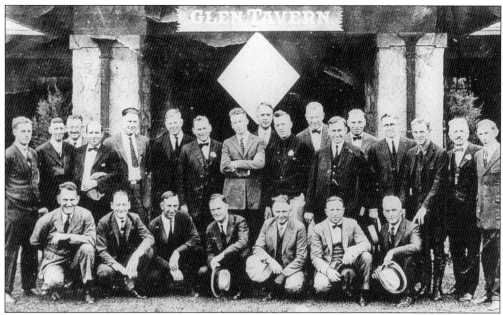

JOINING A NEW SERVICE CLUB, MARCH 1924. Rotary International's charter members gathered in front of the Glen Tavern Hotel. The gentlemen, from left to right, are (first row) Lou Baumgartner, Carl Dwyer, Sam Primmer, Sam Lothridge, Howard Pressey, Murray Wineman, and Wade Gray; and (second row) Charles Chamberlain, John Cauch, Bill Reese, Sid Taylor, J. D. Hill, Cecil Foster, Britt Bowker, Doug McPhee, C. D. Jones, Eddy Le Schofs, Roy Wilson, Ralph Steward, Al Thille, Art Walden, Howard Tubbs, Frank Messeck, and George Caldwell.

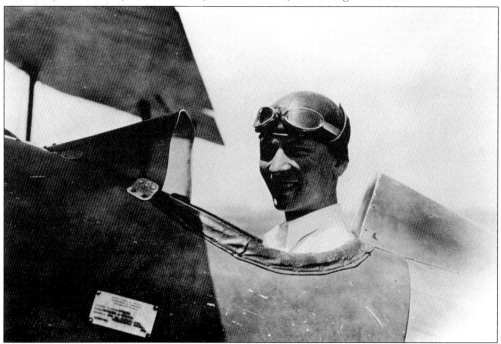

SOARING WITH THE CONDORS. Qualified pilot, local historian, and published author Charles Outland smiles for the camera while in the cockpit of a plane.

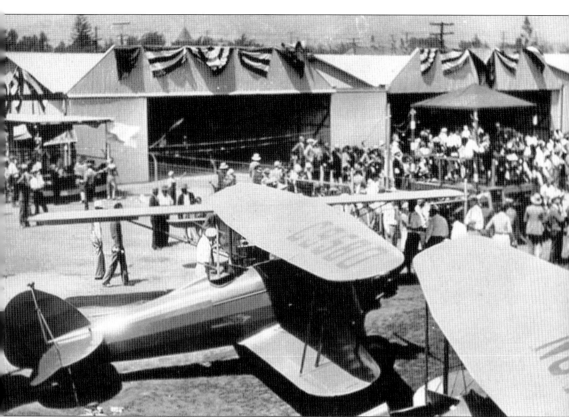

THRILLING TO THE GRAND DEDICATION, AUGUST 1930. The Santa Paula Airport was grandly dedicated with a two-day extravaganza. The *Chronicle* crowed, "Never before in the history of Santa Paula has this city been visited by such a throng of people from everywhere in Southern California." It was estimated that the total attendance was some 6,000. Opening day's celebration included acrobatic flying, aerial races, parachute jumping, the Goodyear Blimp floating by, along with airplane rides, food, music, and a great deal of cheering and hoopla. Out of the St. Francis Dam devastation came the newly leveled and cleared land for the oil-surfaced runway and a few corrugated hangars. It was the realized dream of a handful of flying enthusiasts. Today both their descendants and newcomers continue to preserve the original field and then some. Greatly expanded, the airport rightly claims having one of the largest collections of antique planes and being one of the busiest private airports in the country. Plans are well underway to create the Aviation Museum of Santa Paula.

ACROSS AMERICA, PEOPLE ARE DISCOVERING SOMETHING WONDERFUL. *THEIR HERITAGE.*

Arcadia Publishing is the leading local history publisher in the United States. With more than 3,000 titles in print and hundreds of new titles released every year, Arcadia has extensive specialized experience chronicling the history of communities and celebrating America's hidden stories, bringing to life the people, places, and events from the past. To discover the history of other communities across the nation, please visit:

www.arcadiapublishing.com

Customized search tools allow you to find regional history books about the town where you grew up, the cities where your friends and family live, the town where your parents met, or even that retirement spot you've been dreaming about.